IMAGES
*of America*

# PETALUMA
## A HISTORY IN ARCHITECTURE

Petaluma architect Brainerd Jones's career spanned over 40 years, from the time he opened his office on Main Street in what was then called the Tann Building, until his death in 1945. Jones was not known for any particular style. Like many of his contemporaries, he was adept at many different designs and prepared plans for a variety of building types ranging from Carnegie libraries, school buildings, banks, churches, fraternal halls, commercial structures, residences, fire stations, and more. The *Argus Courier* summed up the importance of his work in an obituary written on March 3, 1945, stating that "perhaps no man has left more living memorials of his achievements and of his contributions to his community than this architect who was a small town architect only in the sense that he lived and worked in a small town." Examples of Jones's work are found throughout this book.

IMAGES
*of America*

# PETALUMA
## A HISTORY IN ARCHITECTURE

Katherine J. Rinehart

Published by Arcadia Publishing
Charleston SC, Chicago IL, Portsmouth NH, San Francisco CA

Printed in Great Britain

Library of Congress Catalog Card Number: 2005929093

For all general information contact Arcadia Publishing at:
Telephone 843-853-2070
Fax 843-853-0044
E-mail sales@arcadiapublishing.com
For customer service and orders:
Toll-Free 1-888-313-2665

Visit us on the internet at http://www.arcadiapublishing.com

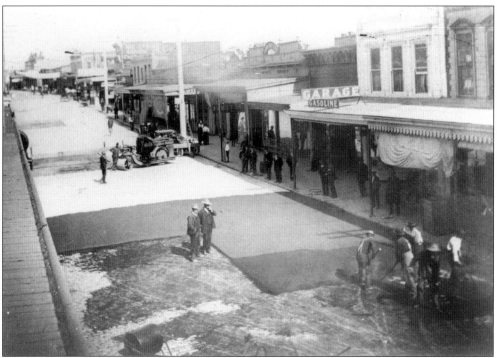

This 1907 image shows the paving of Petaluma's Main Street, which was known as Main Street up until 1958, when the name was changed to Petaluma Boulevard North. The original Third Street is now Petaluma Boulevard South. This change coincided with the opening of Highway 101. At the time, some thought Main Street sounded too old-fashioned for what was perceived as a modern city. (Courtesy of the Sonoma County Library.)

# CONTENTS

# ACKNOWLEDGMENTS

This book includes images from collections maintained by the Sonoma County Library and the Petaluma Historical Library and Museum, many of which were donated by two Petaluma historians, Ed Mannion and Ed Fratini, both now deceased. Without the generosity of these organizations and other individual collections, this book would not have been published. Thank you, Verne Alexander, John Benanti, Sally Brasseur, Dorothy Bertucci, Herb Bundesen, Gloria Campau, Alvin Cooper, Herb Graff, the Hansen family, Tony Hoskins, Marianne Hurley, Lee M. Johnson, Lucy Kortum, Joe Mauro, Daniel Markwyn Ph.D., Kiyo Okazaki, Bill Rinehart, Fred Schram, Jane Soberanes, Jane Thomson at the City of Petaluma, George Tomasini, Lee Torliatt, and Dave Traversi, who provided support, photographs, and/or assisted with research.

The goal of this book is to provide a sampling of architectural styles and building types constructed through the 1950s, rather than a comprehensive documentation of all historic buildings in Petaluma. Availability and quality of historic photographs was a factor; consequently some important buildings were not included.

This book was also made possible by the efforts of several individuals who have researched the history of Petaluma and its wonderful buildings in years past and present. They include, but are not limited to, Dan Peterson, who along with a cadre of volunteers conducted a historic resources survey of Petaluma in 1977 that provides a wealth of information on Petaluma architecture; Don Napoli, who along with the assistance of Debi Riddle, prepared a National Register nomination documenting the importance of Petaluma's commercial district in 1994; Katie Watts of the *Argus Courier*, whose weekly articles provide a plethora of information on Petaluma's past; all those who worked on the Centennial Edition of the *Argus Courier* that came out on August 18, 1955, full of Petaluma history; Shawn Montoya and Ron Bausman, who have been recording the legacy of local architect Brainerd Jones for a number of years; and Skip Sommer, who has documented many aspects of Petaluma's history and buildings in a column for the *Petaluma Post*; Adair Heig, whose book, *History of Petaluma, A River Town*, is a must-read for history enthusiasts; and finally, the late Hoppy Hopkins, Petaluma Museum historian and Petaluma Historical and Cultural Preservation Committee member, who kept history alive for us all.

# INTRODUCTION

Architecture reflects the character and aspirations of the people who practice it. But a building is more than merely a reflection of character traits; it is a testament to what life was like at the time it was constructed. Historic buildings provide a tangible timeline of a community's history, while a building reflects the values of those involved in its construction and design, whether that design was created by a trained architect, a builder, or a homeowner relying on a pattern book. Even altered buildings have a story to tell, as those alterations provide clues to changes in use or reflect changes in the local economy, technology, or society in general.

Petaluma possesses a tremendous variety and quality of architecture constructed over the last century and a half. Beginning in about 1849, a market hunting camp developed in Petaluma along the river. The area's marshes and sloughs had abundant game, which hunters and trappers sold to the hotels in San Francisco for gold-rush-inflated prices. Soon merchants and farmers throughout the North Bay counties discovered that it was more cost effective to ship their goods and produce down the placid Petaluma River than to take the roundabout overland route to Sonoma and Benicia, or risk disaster at one of the coastal ports.

Warehouses sprang up and before long a plat was drawn, and residents began erecting wood-frame buildings, both residential and commercial. Stores began to specialize, and a bank, a newspaper office, and several fraternal halls appeared. New stone and brick buildings gave the downtown a more substantial and permanent appearance.

By the 1870s, with the establishment of the San Francisco and North Pacific Railroad, Petaluma became a major commercial center. Shipments of hay, grain, fruit, potatoes, hops, butter, cheese, eggs, wine, hogs, sheep, cattle, poultry, wood, lumber, and charcoal from the whole of Sonoma and Lake, and a large portion of Marin and Mendocino Counties made their way to Petaluma and then to San Francisco and points beyond. In 1879, Lyman Byce and Isaac Dias invented the first practical egg incubator. Another Petaluman, Christopher Nisson, seized upon this invention and within a few years had established the world's first commercial hatchery.

At this time, the population of California was increasing rapidly as promotional campaigns encouraged farmers, health seekers, and others to move to the "Golden State." This rise in population created greater demand for locally grown foods, including eggs. By 1885, at least 50 Petaluma area farms, most under five acres and family operated, had purchased the newly invented incubator and were hatching baby chicks artificially, both for their own use and for market.

The dairy industry was equally important to Petaluma, which soon became one of the largest producers in Sonoma County and the entire state. By 1880, 76 percent of California's milk,

12 percent of its cheese, and nearly 8 percent of its butter came from Sonoma County, much of it from Petaluma dairies.

Along with the chicken ranches and dairies came the need for supporting businesses such as hatcheries, feed stores, creameries, and even a chicken pharmacy, which created new jobs, a demand for housing, and increased wealth for Petaluma. Evidence of these prosperous times is reflected in the splendid architecture found throughout Petaluma.

Petaluma, a dairy and egg capital, also had a reputation as a major manufacturing center, sometimes called the "Lowell of the West." During the late 19th and early 20th centuries, firms such as the Carlson Currier Company, Lachman and Jacobi Winery, Heynemann Overall Factory, Nolan-Earle Shoe Company, several tanneries, and a woolen mill operated in Petaluma. Many of these firms had relocated from San Francisco following the 1906 earthquake. Unlike much of Marin and Sonoma Counties, Petaluma suffered very little damage during the earthquake because of its distance from the San Andreas Fault. Petaluma's proximity to river and rail transportation made it ideally suited for displaced manufacturers. The local chamber of commerce and the city's businessmen successfully marketed Petaluma's desirability, sometimes even providing property for new factories.

Although many associate the 1930s with the Great Depression and mass unemployment, in Petaluma it was also an era of construction projects, including the grading of 1,292 linear feet of city streets, the painting of seven city schools, construction of a post office, fire station, sewage treatment plant, storm sewers, Wickersham Park, and a new D Street Bridge. All of these were funded by the Works Progress Administration (WPA) and the Public Works Administration (PWA).

The 1940s saw the decline of Petaluma's role as the Egg Basket of the World as advancements in technology, such as wire cages and artificial lighting, made it possible for other areas with a less favorable climate and soil to raise chickens more cheaply. The invention of the pneumatic tire during World War I and the construction of the interstate highway system during the 1950s and 1960s meant that eggs could be transported by refrigerated trucks rather than by train, making Petaluma's proximity to the railroad and river of no particular advantage.

On January 1, 1950, the *Argus Courier* reported that employment in Petaluma was continuing a downward spiral, with construction at a standstill. A surplus of dairy and poultry workers, low prices for eggs, and high feed costs depressed the local economy. Highway 101 was completed in 1957, bypassing downtown. In conjunction with a sometimes sluggish economy, managed growth policies of the 1970s and a dedicated preservation community have resulted in the protection of many of the architectural jewels that have earned Petaluma its reputation as one of the movie industry's favorite locations for "Main Street America."

# One

# 19TH CENTURY COMMERCIAL

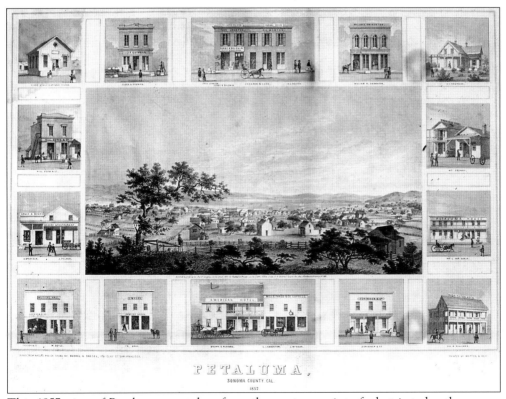

This 1857 view of Petaluma was taken from the vantage point of what is today the corner of Washington and Howard Streets, looking east toward the river. (Courtesy of the Sonoma County Library.)

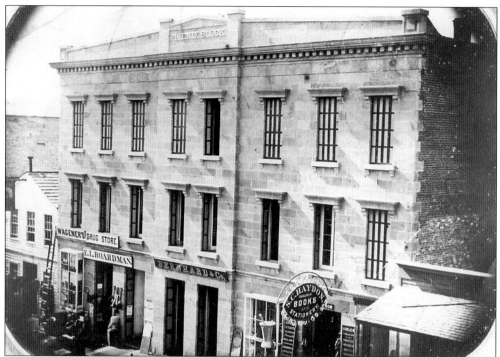

The 1850s and 1860s saw the incorporation of the City of Petaluma and its transformation from what was considered little more than a hunter's campsite to the commercial hub of Sonoma County with the construction of warehouses and permanent residences. Many of the new buildings were constructed of stone or brick, such as the imposing three-story Phoenix Block built by Dr. William R. Wells in 1856, which gave the town a more substantial appearance. (Courtesy of the Sonoma County Library.)

Dr. Wells's Phoenix Block was torn down in 1929 and replaced by the current Phoenix Block, a one-story building erected by George P. McNear, which for many years was home to Woolworth's. (Courtesy of the Sonoma County Library.)

Hotels were some of the first buildings to be constructed downtown. The American Hotel was built in 1852. It burned in 1868 and was rebuilt only to burn again. This photograph shows the third and final American Hotel, which was constructed in 1873. It was demolished in 1966, when the city condemned it. The vacant lot that resulted was later occupied by the present-day Putnam Plaza. (Courtesy of the Petaluma Museum.)

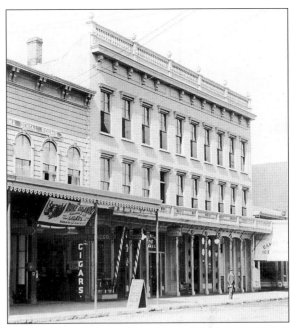

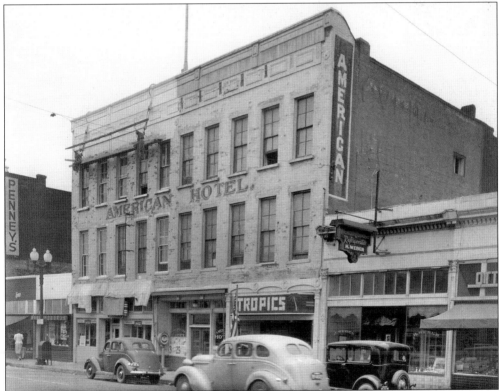

Architecturally, the American Hotel represented a typical commercial masonry building of the 19th century. Note the amount of architectural detailing that had been lost or changed by the late 1930s when this picture was taken, including the removal of window hoods and the decorative cornice, and alterations to the first-floor entrance. (Courtesy of the Sonoma County Library.)

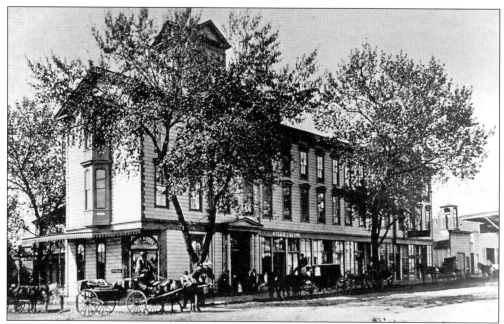

The City Hotel was supposedly constructed and moved from Vallejo to the southwest corner of Western Avenue and Kentucky Street by Col. C. H. Veeder in 1853. (Courtesy of the Sonoma County Library.)

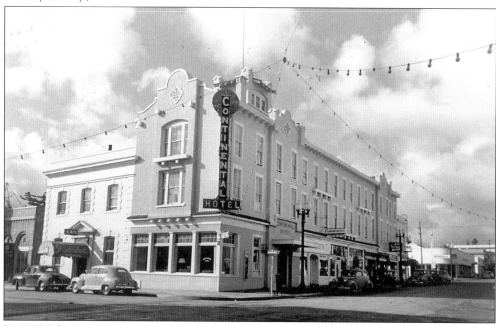

In 1905, John Lepori, a Napa County capitalist, had the building remodeled by contractor R. W. Moller. At some point, the name changed from the City Hotel to the Continental Hotel and, in 1914, further remodeling was done under the direction of contractor H. S. McCargar that resulted in a Mission Revival–style building designed by local architect Brainerd Jones. A May 1968 fire destroyed the building, and the site is now occupied by Washington Mutual Bank. (Courtesy of the Petaluma Museum.)

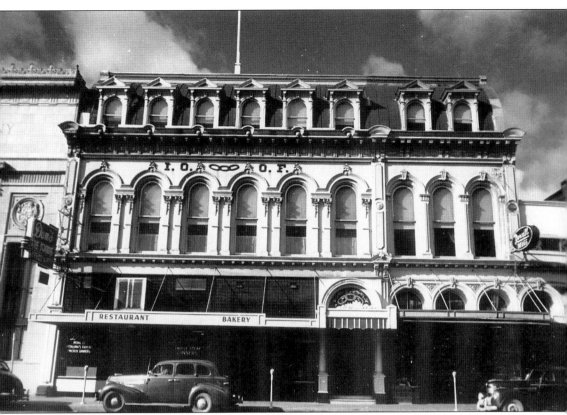

As was the case in other towns of consequence, an Independent Order of Odd Fellows building was constructed early in Petaluma's history. The Petaluma chapter of the IOOF was founded in 1854. The IOOF, a benevolent society that originated in Manchester, England, was devoted to offering social asylum to strangers, or odd fellows. In 1865, the IOOF purchased a site where they later built a permanent home for their lodge, which was designed in the Second Empire style by architect J. B. Brooche. As was typical of lodge buildings, the IOOF headquarters accommodated commercial uses on the first floor, generating income for the IOOF members. In February 1926, the IOOF awarded a contract to the Vogensen Construction Company to remodel both the interior and exterior of the building. This work included incorporating an addition to the north and installing a heating system. The contract price was $25,000. Brainerd Jones prepared the plans. (Courtesy of the Sonoma County Library.)

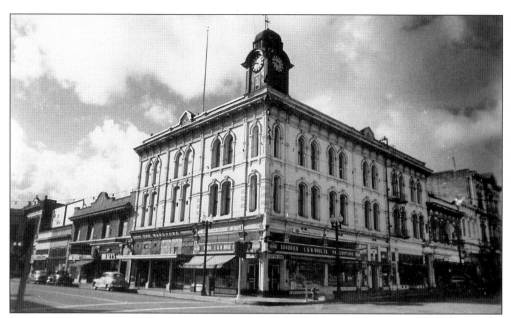

By the 1880s, two other lodge buildings joined the IOOF downtown on Western Avenue. The Masonic Building was designed by William Schrof and constructed in 1882. The Mutual Relief Building was designed by John Curtis in 1885. Like the IOOF Building, both feature cast-iron facades. However, unlike the IOOF, which was designed in the Second Empire style with its mansard roof, the Masonic and Mutual Relief Buildings were designed in the Italianate style, characterized by bracketed cornices with pediments, arched windows, pedimented window caps, and paneled pilasters. (Courtesy of the Sonoma County Library.)

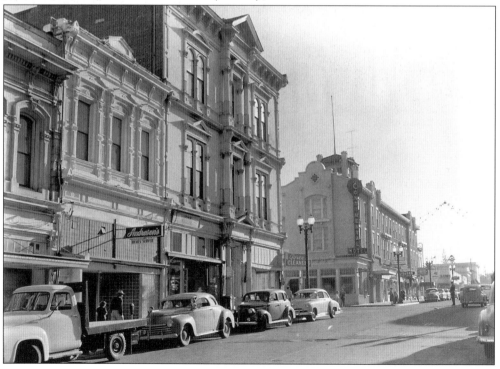

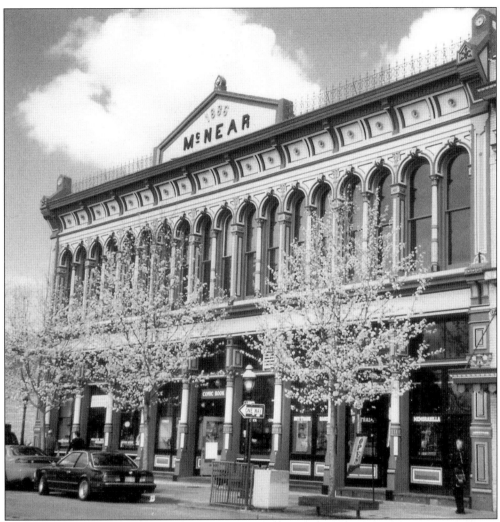

The IOOF Building, the Masonic Building, and the Mutual Relief Building all feature cast-iron facades. Constituting one or more exterior walls, these facades were composed of multiple parts, each cast separately in a sand mold, with a wooden pattern being carved for each section. Industrialized architecture, much of it coming to Petaluma from one of San Francisco's many ironworks, had arrived with this mass production of identical, interchangeable elements, providing an easy, economical, and efficient way to decorate commercial structures. While cast-iron fronts were also thought to provide fireproofing, this proved to be false. The McNear Building at 7 Fourth Street is an excellent example of a cast-iron–fronted building. The building seen above, and its neighbor, which is also known as the McNear Building, received major restoration work in 1978 thanks to the buildings' owners, Jeff Harriman and Wally Lourdeaux, in cooperation with the Petaluma Community Development Agency. (Photograph by Katherine J. Rinehart.)

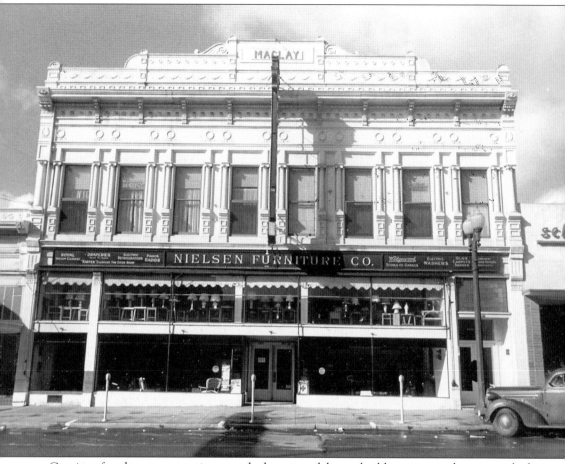

Cast-iron facades were sometimes used when remodeling a building, as was the case with the Petaluma Opera House at 149 Kentucky Street. Built by the Washington Hall Association in 1870, the Petaluma Opera House was on the circuit for theatrical and concert groups and lectures from San Francisco. The building provided a distinctive setting to many theatrical events, lectures, dances, parties—everything except opera, it would seem. Architects of the 1870 building were S. H. Williams and Son of San Francisco. In 1901, the Washington Hall Association sold the building to Adolph Bloom for $4,420. Although his original intention was to keep the opera house open as a theater, he decided to engage Brainerd Jones to design a remodel that would convert the building to office and meeting space on the second and third floor, and retail on the first floor. That remodel resulted in a dramatic alteration to the facade, including application of decorative sheet metal with Eastlake and Beaux Arts detailing that can be seen on the building today. The Petaluma Opera House is often referred to as the Maclay Building, after Thomas Maclay, who purchased the building in 1927. Following his death in 1944, the building was sold to Ernest C. Nielsen, who operated a furniture store there until 1960, when it was leased to Robert M. Wilson. The building was recently renovated and received a Heritage Homes Award in 2003. (Courtesy of the Petaluma Museum.)

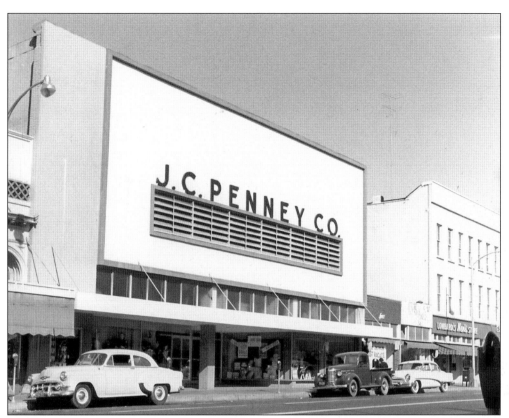

Sometimes remodeling resulted in the covering of a cast-iron facade, as is the case with a building at 119–123 Petaluma Boulevard North, which was constructed during the 1880s. The existence of the cast-iron pilasters at each end of this building's current facade is the only hint of what may be under its 1950s stucco and tile slipcover. The building has been occupied by several department stores over the years including the Racket, Raymond Brothers, the Leader, J. C. Penney, and Marin Outdoors. Using an interest-free loan of up to $200,000 provided by the City of Petaluma Redevelopment Agency, current owner Stephen Lind hopes to restore the building to its former glory in the near future. (Courtesy of the Sonoma County Library.)

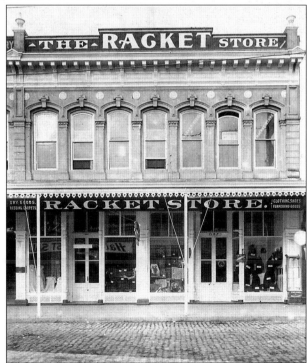

The Herold Building, shown here at the corner of Kentucky and Washington Streets, is one of the few examples of the Queen Anne style found in Petaluma commercial construction. Originally the site of the Washington Stable and Livery, this two-story brick building was constructed in 1899 for Angela Canepa, an enterprising widow who invested extensively in Petaluma real estate, by local contractor Samuel Rodd for just over $12,000. The original specifications called for commercial space on the first floor and residential apartments on the second. By the 1920s, the second floor was occupied by medical and dental offices. The building started out with three angled, upper bay windows on the Washington Street side, but was extended in 1923 to include two additional bays. Harry Herold, the owner of the building at the time, hired H. S. McCargar to do the work. In 1987, engineer and contractor Frank Rosenmayer purchased the building and undertook a complete restoration that included recreating the tower's cap, which had been missing for a number of years.

# Two

# 20TH CENTURY COMMERCIAL

This 1944 view of Washington Street, looking east, shows the former Weller Hopkins building in the foreground on the left. Constructed in 1874 for Manville Doyle, founder of the Exchange Bank, the building was torn down in 1961 and replaced by Sierra National Bank. West America Bank now occupies the site. (Courtesy of the Sonoma County Library.)

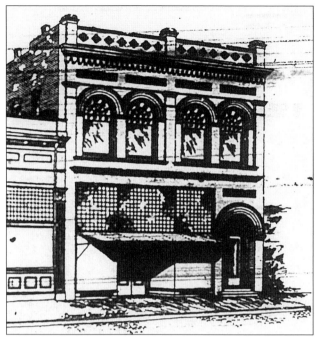

Brainerd Jones chose the Second Renaissance Revival style for the Schluckebier-Gwinn Building at 133 Kentucky Street, which he designed in 1904. R. W. Moller and William C. Stradling, who constructed the building, had also been involved with building the Carnegie Library, which exhibits similar brickwork. Henry Schluckebier was a successful hardware man and real estate investor and J. H. Gwinn was a banker. (Courtesy of the *Petaluma Argus*, October 21, 1904.)

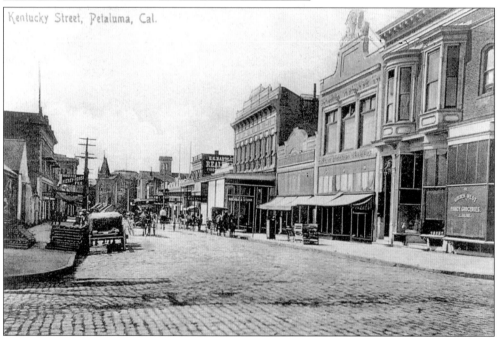

The D. J. Healey Building, also built in 1904 on the same block, is located at 155–157 Kentucky Street next door to the Herold Building, the second building on the right in this photograph. Now known as the Gwinn Building, it was designed by San Francisco architect Lionel Deane and built by contractor M. H. Fredericks. William C. Stradling did all of the concrete and brick work, which consists of Alameda pressed bricks. In 1923, new owner J. H. Gwinn hired H. S. McCargar to remodel the building, which presumably resulted in its current appearance, sans the tall parapet. (Courtesy of the Petaluma Museum.)

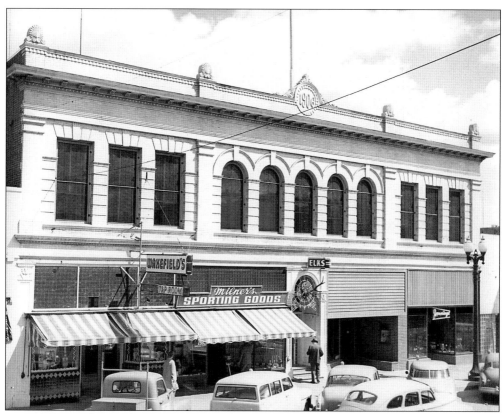

In 1906, Brainerd Jones designed the Doyle Building, or the Elks Hall as it was sometimes called, on Kentucky Street for Manville Doyle. This substantial brick building, which stood where Copperfield's Books is today, was demolished in 1964 following a fire. (Courtesy of the Petaluma Museum.)

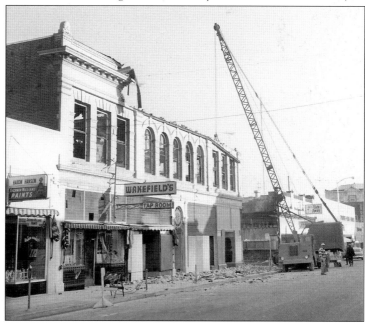

Pictured here is the Doyle Building being demolished following a June 30, 1964 fire. Newspaper headlines proclaimed it as the worst fire since 1952, with six Kentucky Street businesses damaged in a pre-dawn blaze. (Courtesy of the Sonoma County Library.)

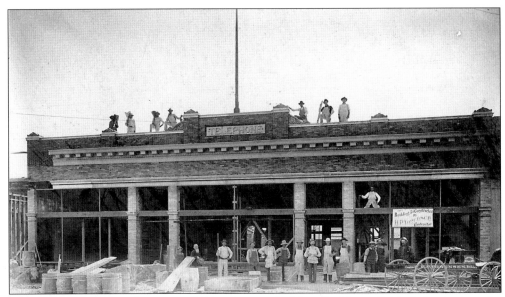

Brainerd Jones was hired again in 1907 to design a building for Henry Schluckebier, across the street from the Doyle Building at 131 Kentucky Street, on the site of the Schluckebier family home pictured below. The telephone company was the first to move in. Today Aram's Cafe, Kentucky Street Antiques, and We Create occupy this building. (Courtesy of the Petaluma Museum.)

Henry Schluckebier was a banker and a merchant. Some may remember the Schluckebier Hardware Stores on East Washington and Main Streets. Mr. Schluckebier was responsible for construction of several Kentucky Street buildings. (Courtesy of the Sonoma County Library.)

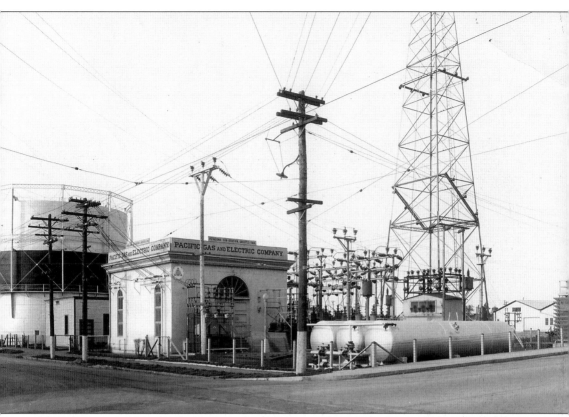

Although not an example of commercial architecture, the Pacific Gas and Electric Building at the northeast corner of D and First Streets is worth mentioning given its proximity to the downtown where industrial and commercial building have historically coexisted. Completed in 1910, the PG&E Building replaced the gas works that stood across the street. A *Petaluma Argus* reporter described the "splendid new substation" as being 80 by 50 feet in size and constructed of brick with a steel-truss roof. In addition to the main building, there was a battery of four immense boilers of 1,000 horsepower each and a 2,000-horsepower, single-unit engine that was considered to be the finest and largest of its kind in California at the time. This plant was good news for Petaluma factories and manufacturing plants, as well as light consumers, who were now guaranteed continuous service at all times, which was of great importance when marketing the city to potential investors. (Courtesy of the Petaluma Museum.)

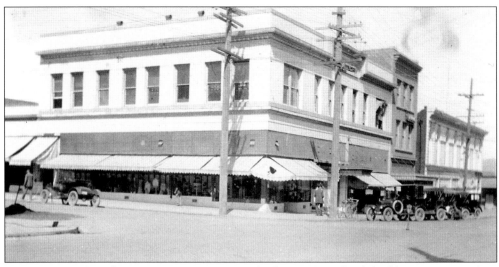

In 1910, Santa Rosa businessman Morris Prince had a two-story brick building constructed on the northeast corner of Western Avenue and Kentucky Street by contractor Ernest L. Young. The Prince Building was home to many businesses over the years such as the Toggery, the Arcade Barber Shop, Pedroni Delicatessen, Antler's Pharmacy on the first floor, and furnished rooms, doctor, dentist, and lawyers' offices on the second. The building features a glazed-brick exterior with terra-cotta trim. (Courtesy of the Sonoma County Library.)

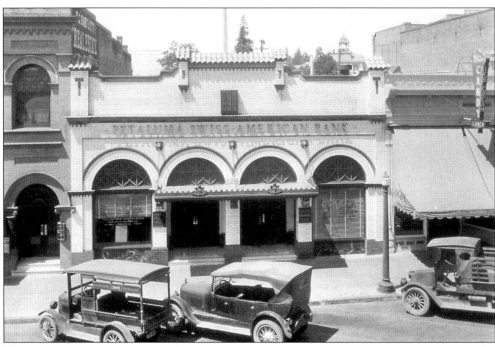

Glazed brick was also used on the former Swiss-American Bank Building at 137 Kentucky Street. Like the Prince Building, the Swiss-American Bank Building was constructed in 1910. Fanny Newburgh, wife of *Petaluma Argus* editor Art Newburgh, hired Brainerd Jones to design this Mission Revival–style building, and contractor H. P. Vogensen to build it. (Courtesy of Shawn Montoya.)

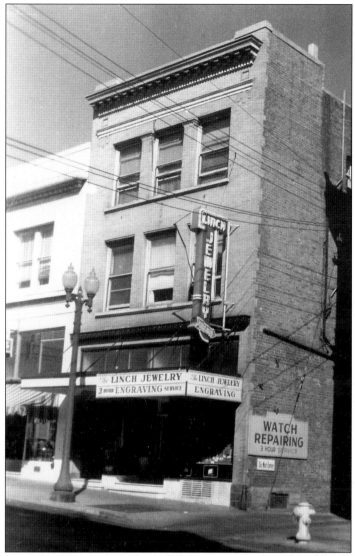

Petaluma's first steel-framed commercial building was constructed in 1910 at 10 Western Avenue when W. H. Van Marter hired Brainerd Jones to design a second story for an existing brick building (built in the late 1870s and home to Baldwin Restaurant and Bakery) to accommodate a rooming house. The steel-frame reinforcement was manufactured by Mortensen Company in San Francisco and shipped to Petaluma via the Petaluma River. William Stradling did the brickwork and contractor Ernest L. Young all the woodwork. During construction, Van Marter decided to add a third floor. In 1918, the building underwent additional remodeling. William Van Marter died in 1919 and in 1928, his daughter, Mrs. Walter Peck, purchased the property. The Baldwin Restaurant and Bakery went out of business at the same time and Peck leased the first floor to Purity Company, a chain grocery store. In 1946, Linch Jewelry, with which many associate this building, opened for business. The current owner, Bixler Barclay Properties, purchased the building in 2000 and immediately took on a major rehabilitation, that restored the second and third-floor units to office space. This work earned the company awards from the Sonoma County Historical Society and Heritage Homes of Petaluma. (Courtesy of the Sonoma County Library.)

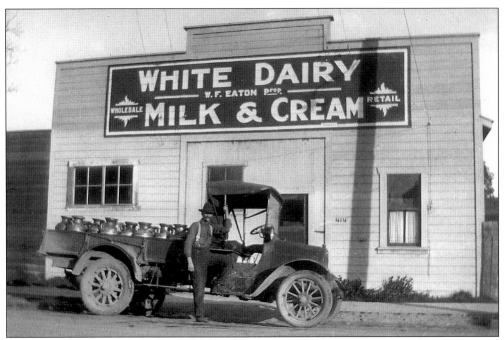

It is important to recognize that not all of Petaluma's early commercial buildings were of a particular design or of substantial proportions. Despite the economic prosperity of the town, many commercial structures built during the 19th and 20th centuries were simple in construction and design and reflected a utilitarian approach to architecture. Often these buildings were constructed of wood, with a false front, such as the White Dairy located at 414 East Washington Street. (Courtesy of the Petaluma Museum.)

This c. 1906 livery stable that once stood at the northwest corner of First and D Streets is another example of a false-front building. This local landmark was moved to McNear Island when plans to build a four-story garage on its site were approved. (Courtesy of the Sonoma County Library.)

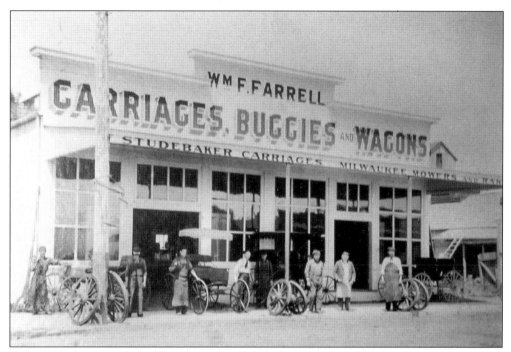

Sometimes these simple buildings were remodeled when their merchandise changed, as was the case with William F. Farrell Blacksmith and Wagon Maker at 269 Petaluma Boulevard North. (Courtesy of the Petaluma Museum.)

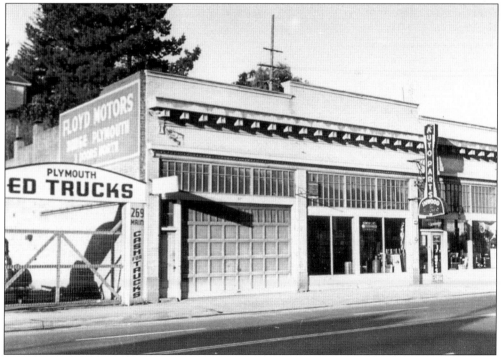

Pictured here is the same building in the 1940s, when it was occupied by Floyd Motors and Inwood Auto Parts. (Courtesy of the Sonoma County Library.)

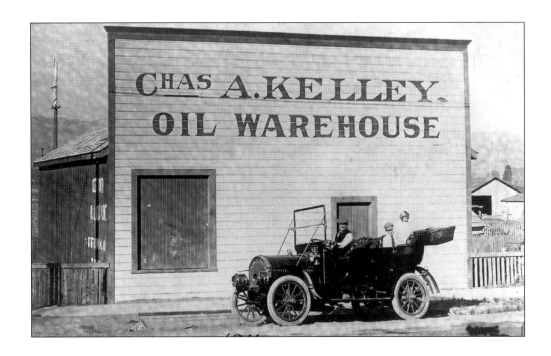

In other cases, it was not so much the change in merchandise as a change in technology that resulted in alterations to a building's appearance, as seen here with Charles A. Kelley's gas station at 619 Petaluma Boulevard South. Charles A. Kelley was born in Vermont in 1860 and came to Petaluma as a boy. As an adult, he was considered one of Petaluma's pioneer gasoline dealers, starting with one tank of gas and a bucket and then expanding the business as a representative of the Shell Company when they opened a branch here. (Courtesy of the Sonoma County Library.)

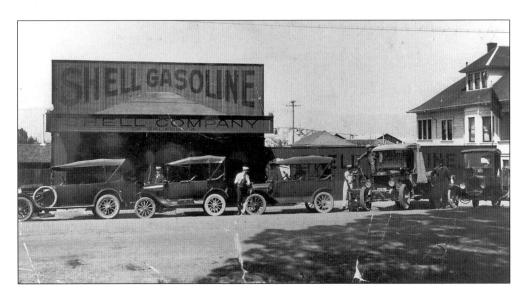

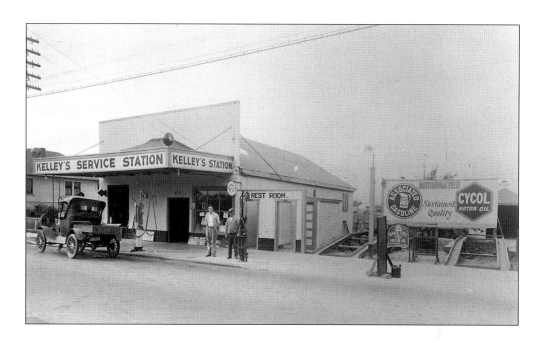

Pictured above is Kelley's Service Station as it looked in 1925. Below, Walter Strayer's Shell station occupies the building in the 1950s. The Kelley home is visible to the right. By this time, Frederick Kelley was operating Kelley's Richfield Service Station across the street at 700 Petaluma Boulevard South. (Courtesy of the Sonoma County Library.)

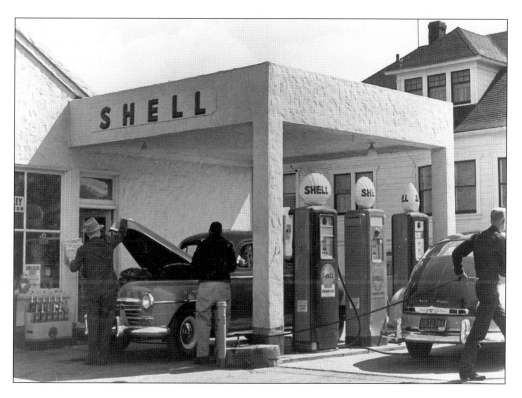

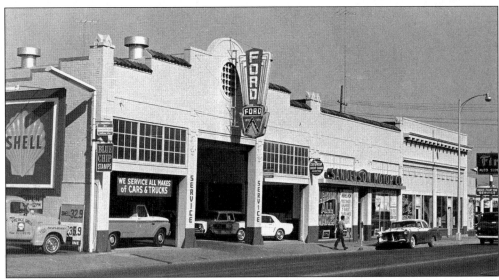

Many of the commercial buildings constructed in Petaluma during the early decades of the 20th century are modest examples of the Mission Revival style, which draws on the shape and form of Spanish missions. Typically, these buildings include stucco, brick, or concrete walls and red tile roofing. Quatrefoil windows are common. Brainerd Jones used the Mission Revival style for buildings he designed for George P. McNear, occupied by Sanderson Ford Motor Company. The portion of the dealership shown to the right was built in 1917 and the left side in 1923. The building is a contributor to the Downtown National Register District. In 2000, a proposal calling for its demolition so that a hotel could be built, fell through. In 2001, the same development company came back with a plan to convert the existing building to commercial and office space. (Courtesy of the Petaluma Museum.)

Like the Sanderson Ford Motor Company Building, this structure at 19–25 Kentucky Street also exhibits the Mission Revival style. (Courtesy of the Petaluma Museum.)

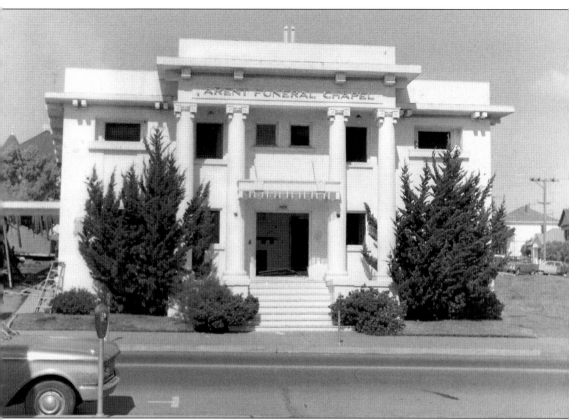

Not all buildings constructed during the early decades of the 20th century were in the Mission Revival style. In 1916, Brainerd Jones designed a neoclassical funeral home for Dennis J. Healey with Clark Trendall as the contractor. A *Petaluma Daily Courier* reporter described the building in a November 26, 1916, article by stating that "while in general style the building might be termed Colonial, an effort has been made throughout both exterior and interior to depart as far as consistent from tradition and periods, and to design a simple, well proportioned building that would be practical, convenient and pleasing." By the 1950s, when this picture was taken, it was owned by Arthur W. Parent. The building was located at 216 Washington Street between Keller and Liberty Streets. A parking lot for West America Bank is now located where the funeral home once stood. (Courtesy of the Sonoma County Library.)

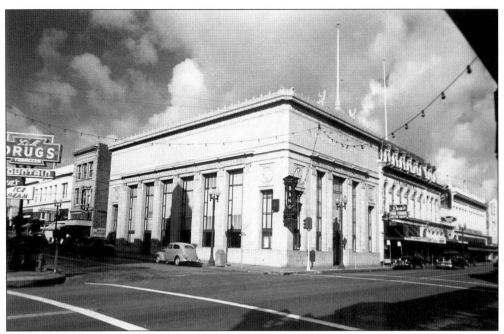

The 1920s brought yet more architectural styles to downtown Petaluma with the construction of two banks, both built in 1926. The Petaluma National Bank, established in 1903, found a new home at the northwest corner of Petaluma Boulevard and Western Avenue. Designed by San Francisco architects Hyman and Appleton, this building exhibits elements of the neoclassical style. (Courtesy of the Sonoma County Library.)

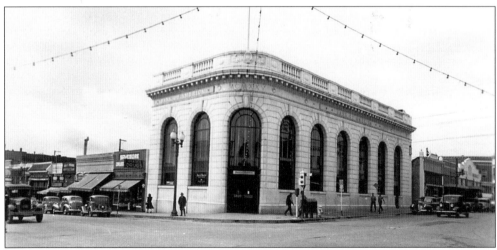

Designed in the Second Renaissance Revival style by H. H. Winner of San Francisco, the Sonoma County National Bank built its third home at the southwest corner of Petaluma Boulevard and Washington Street. Upon completion, C. A. Miller, secretary of the Petaluma Chamber of Commerce, remarked that the "beautiful new building now stands as a monument to the prosperity and stability of our community and its principal industries." (Courtesy of the Sonoma County Library.)

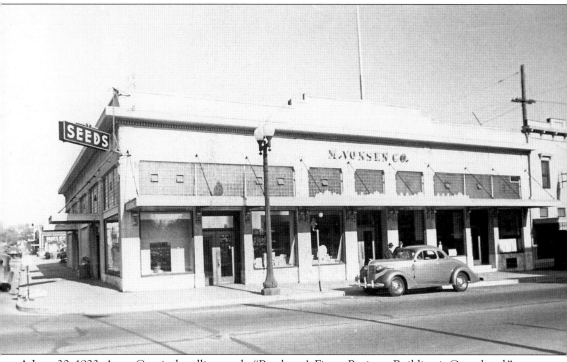

A June 30, 1923, *Argus Courier* headline reads, "Petaluma's Finest Business Building is Completed," in reference to the M. Vonsen Company Building at the northeast corner of Western Avenue and Keller Street. Brainerd Jones was the architect and H. P. Vogensen the contractor. The same article describes the building as follows: "for warmth in winter, coolness in summer, sunshine, ventilation and comfort have been made in its planning and construction and there is not a more substantial building on the coast. Mr. Vonsen could have saved several thousand dollars in omitting certain construction, but figured that the best is none too good and he has erected a structure that is a monument to his enterprise, public spirit and progressiveness and has set an example which Petaluma capitalists should emulate." Magnus Vonsen died in 1954, and by 1960, the building, which was then owned by Dr. William Lee, was demolished. Prior to its demolition, the building served as headquarters for those organizing Petaluma's centennial celebration for 1958. A parking garage now occupies the site. (Courtesy of the Sonoma County Library.)

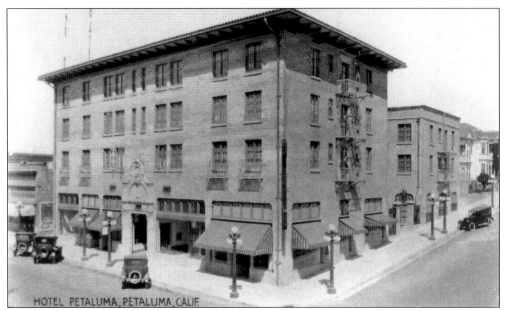

In 1923, construction of the Mediterranean-style Hotel Petaluma was completed after many years of planning. The total cost of the structure and site was estimated to be $325,000, of which $250,000 came from 850 Petalumans who had purchased shares of stock as part of a chamber of commerce campaign. A Hotel Petaluma Company was established with Thomas Maclay as president, George P. McNear as vice president, D. W. Batchelor as treasurer, and Fred S. Howell as secretary. Although Brainerd Jones made a proposal to design the hotel, it was Frederick Whitton, a San Francisco architect, who got the job, having impressed many of the principals with his design for the Eureka Inn in 1922. (Courtesy of the Sonoma County Library.)

For many years, Hotel Petaluma was the center of social gatherings and the place to stay whether traveling through the area or visiting relatives or friends in town. The Petaluma Elks Lodge 901 purchased the building from the Hotel Petaluma Company in 1959 for $91,160. (Courtesy of the Petaluma Museum.)

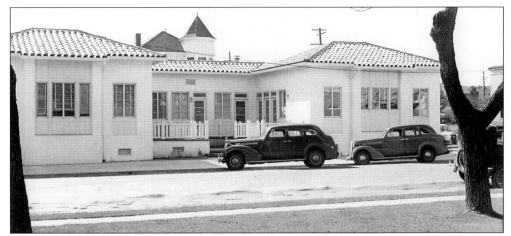

In 1938, Mr. and Mrs. C. C. Boyson built a medical office building at the southwest corner of Fourth and D Streets that was estimated to have cost $20,000. The Boysons chose the Mediterranean style, which complemented the neighboring post office building that had been completed in 1932. (Courtesy of the Sonoma County Library.)

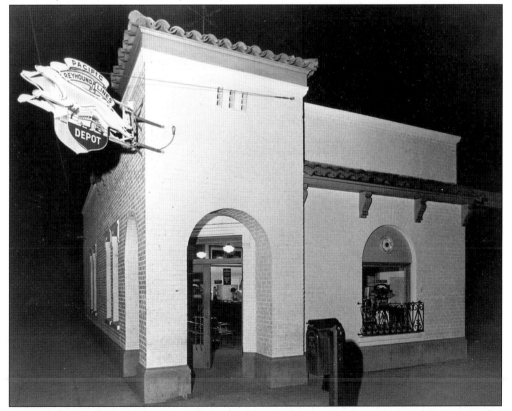

The former Greyhound bus depot, located at the northwest corner of Fourth and C Streets, also represents the Mediterranean style. Santa Rosa architect John Easterly designed the building for George P. McNear in 1939. Other buildings designed by John Easterly include Healdsburg Elementary School, Healdsburg High School gymnasium addition, and the Sonoma County Hospital. (Courtesy of the Sonoma County Library.)

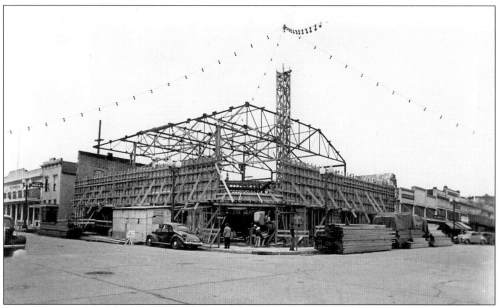

The few commercial buildings constructed in Petaluma during the 1940s were often designed in the Streamline Moderne style, which is characterized by soft or rounded corners, flat roofs, and smooth wall finishes with surface ornamentation. Horizontal bands of windows, frequently made of glass blocks, are used to create a distinctive streamlined or wind tunnel look. The style reflected the growth of speed and travel in the 1930s, and buildings were often modeled after ships and airplanes. Constructed in 1941, the former Leader Building, which many remember as Carithers Department Store or more recently as Couches Etc., is an example of this style. It replaced what had been known as the Case Block at the northwest corner of Western Avenue and Kentucky Streets. (Courtesy of the Sonoma County Library.)

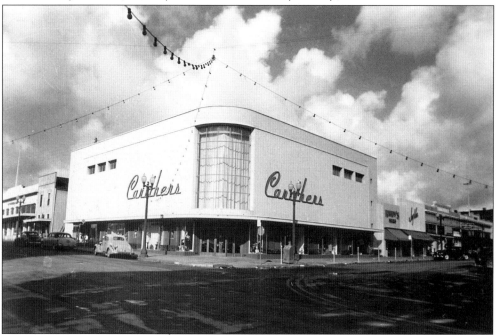

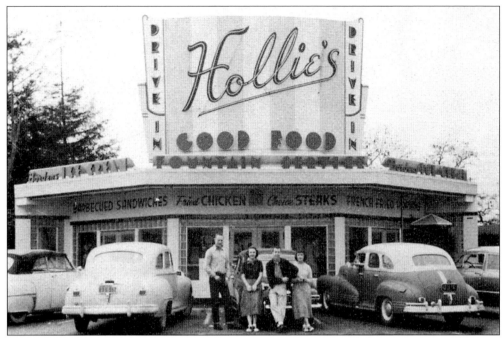

When the automobile left its mark along the country's main streets with the construction of drive-in restaurants and motor courts, Petaluma's thoroughfares were no exception. In 1946, August Lepori and Clarence Haynie constructed a 46 by 48 foot octagonal glass and tile structure on their lot at the corner of I Street and Petaluma Boulevard South and leased it to Alvin Quinley, who established one of the first drive-ins in the North Bay. Quinley, a native of Fresno who moved to Santa Rosa as a young child, had managed a cafeteria in Richmond prior to military service in World War II. Quinley's Drive-In was an immediate success; however, it was only Quinley's until 1948, when it was sold to Hollie Heglin, a GI from Wisconsin. (Courtesy of the 1952 Enterprise Yearbook.)

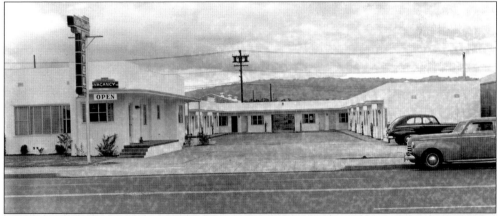

On June 13, 1948, the Casa Grande Motel opened for business at 307 Petaluma Boulevard South. This type of motor court became popular after World War II when architects, responding to building material shortages, were looking for ways to save money when designing roadside lodging. The Casa Grande Motel, with its modest Streamline Moderne detailing, represents an era of Petaluma's history when the automobile dramatically changed how and where buildings were constructed. The City of Petaluma plans to demolish the motel and build a three-story fire station in its place. (Courtesy of the Sonoma County Library.)

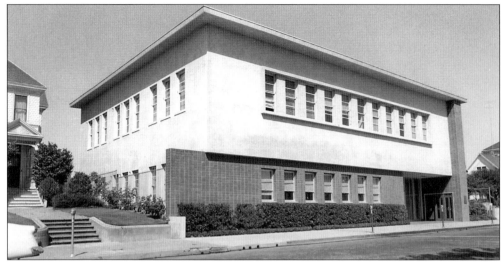

The 1950s saw considerable change in the design of commercial architecture. The post–World War II era brought new attitudes derived from the European modernism of the 1910s and 1920s that rejected the use of historical references. The new concept focused on form and space, giving rise to a style called International. The Pacific Telephone Building, completed in 1951 on Liberty Street, represents an unpretentious example of the International style. Walter Olsen was the contractor on this project. (Courtesy of the Sonoma County Library.)

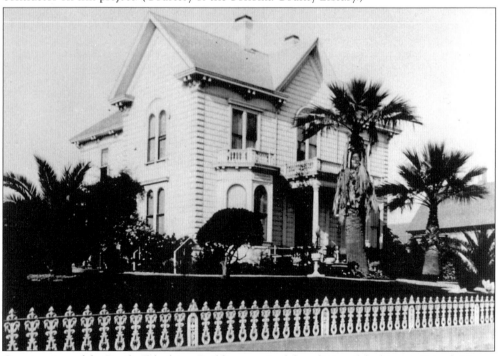

Construction of the Pacific Telephone Building required demolition of the historic Fritsch Home. A native of France, John Fritsch established Petaluma's first carriage and wagon factory along with William Zartman and James Reed. At the time of its demolition, the house had been vacant for 10 years. All of the lumber, three antique fireplaces, and other materials were sold prior to its final razing in November 1949. (Courtesy of the Sonoma County Library.)

# *Three*

# MANUFACTURING, AGRICULTURE, AND TRANSPORTATION

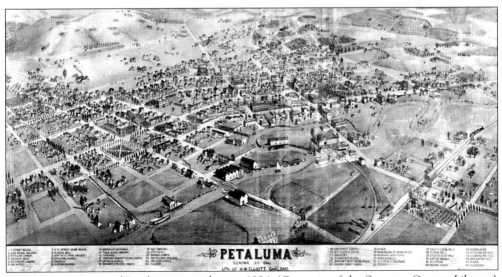

This bird's-eye view of Petaluma was taken in 1884. (Courtesy of the Sonoma County Library.)

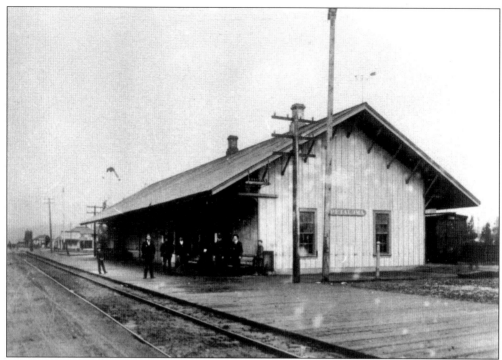

Petaluma became the commercial hub of Sonoma County during the mid-19th century largely because of its proximity to rail and river transportation. Products were brought to Petaluma from surrounding towns, and Petaluma itself became a desirable place to locate a manufacturing business. Petaluma was well suited to poultry and dairy farming, which contributed significantly to the town's economic prosperity. These industries were initially dependent on the San Francisco and North Pacific Railroad that started regular service in Sonoma County on October 31, 1870. Petaluma's depot was completed in 1871 and was located at the corner of East Washington and Hopper Street. (Courtesy of the Sonoma County Library.)

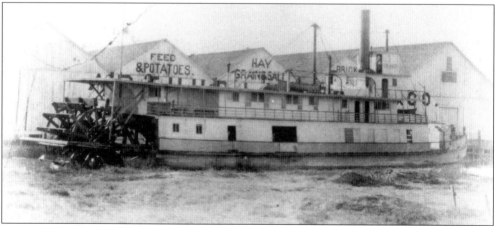

Passengers and cargo were transported to San Francisco by side-wheel steamers that made the trip down the Petaluma River to the San Francisco Bay Area. (Courtesy of the Sonoma County Library.)

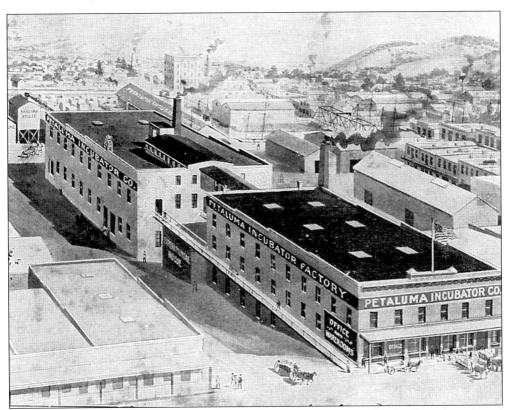

Initial interest in constructing the railroad lay in the desire to transport lumber from the redwood groves north of the Russian River to San Francisco. However, farmers also benefited as refrigerator cars made it possible to ship locally grown fruits, vegetables, and dairy products across the country. The refrigerator car was not the only technological advancement to help farmers. In 1879, two Petalumans, Lyman Byce and Isaac Dias, invented the first practical egg incubator. It was not long before the Petaluma Incubator Company, shown here, was established at what is now known as 242 Petaluma Boulevard North. (Courtesy of the Sonoma County Library.)

This building was torn down in 1959, long after it had ceased operation as an incubator company. (Courtesy of the Sonoma County Library.)

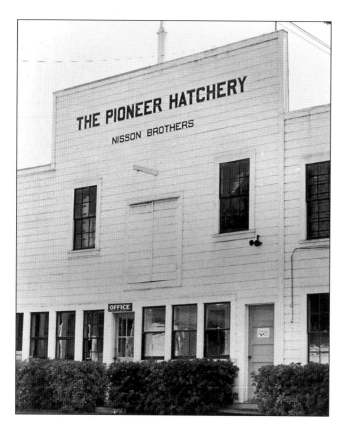

Another Petaluman, Christopher Nisson, seized upon the invention of the incubator and within a few years had established the world's first commercial hatchery. Once located at 418 Sixth Street, this building is no longer standing. (Courtesy of the Sonoma County Library.)

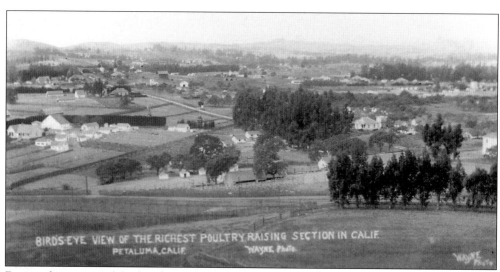

During this time, California's population was also increasing rapidly as promotional campaigns succeeded in encouraging thousands of farmers, health seekers, and others to move to the Golden State. The rise in population created greater demand for locally grown foods, including eggs. Soon chicken ranches began dotting the Petaluma landscape. Farms were typically one to five acres in size and family owned. (Courtesy of the Sonoma County Library.)

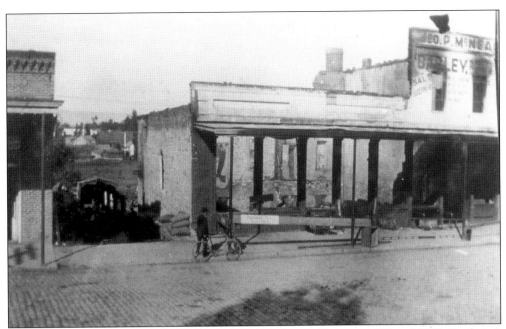

As interest in chicken ranching grew, so did the population. Between 1900 and 1920, Petaluma's population doubled from 3,871 to 6,266. Every new farmer swelled Petaluma's output of eggs and chickens so that by 1915, the district was shipping out an estimated 10 million eggs a year at an average of 30¢ per dozen. These chickens needed feed, coming in large part from the G. P. McNear Company, which had moved its headquarters from Petaluma Boulevard North to B Street in 1902 (shown below) following a devastating fire, as seen above. (Courtesy of the Sonoma County Library.)

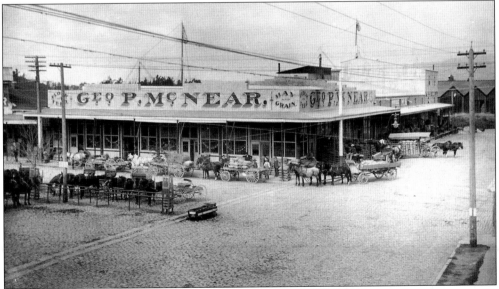

The view above shows the office portion of the mill complex at the northeast corner of B Street and Petaluma Boulevard South, now the site of a parking lot. In 1975, the remainder of the mill was slated for demolition when realtor Skip Sommer bought and rehabilitated it for commercial use.

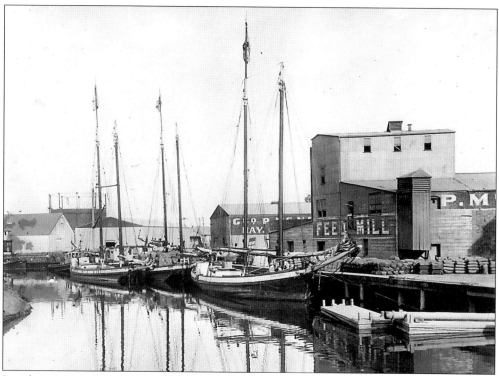

In relocating to the new site on B Street, the G. P. McNear Company was able to take full advantage of the river for transporting goods, as can be seen in this 1912 view. (Courtesy of the Sonoma County Library.)

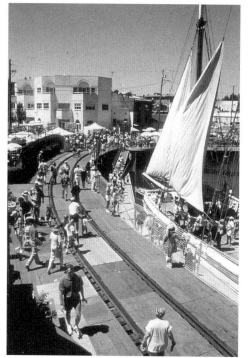

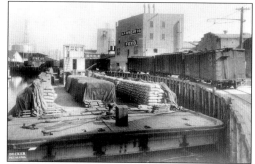

Pictured above in the 1930s, the railroad trestle, a wooden platform built to support the Petaluma and Santa Rosa Railroad, was built in 1922. The trestle further enhanced McNear's ability to get products to and from market now that he had river and rail transport so near the mill. (Courtesy of the Sonoma County Library.)

In more recent years, the trestle has served as a promenade (pictured at left) enjoyed by Petalumans and visitors alike. (Courtesy of the Petaluma Museum.)

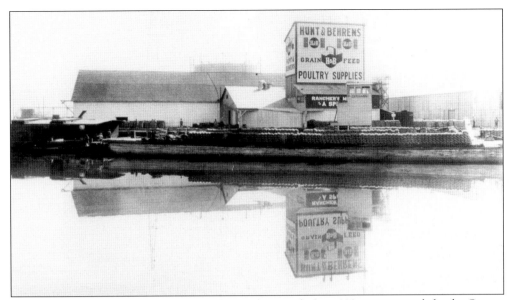

Marvin Hunt was a pioneer Petaluman who, at the age of 15 in 1892, went to work for the George P. McNear Company. In 1921, he formed a partnership with Carl N. Behrens, also a former employee of the George P. McNear Company and longtime Petaluma resident, and opened Hunt and Behrens, a feed and grain mill, at the foot of C Street. Hunt stayed active in the company until his retirement in 1947. Carl Behrens remained with the company, and his son Ed and son-in-law Earl Egan eventually joined the partnership. Carl Behrens was president of the company until January 1966, passing away just six months later. (Courtesy of the Sonoma County Library.)

In 1947, Hunt and Behrens moved to its present facility on Lakeville Street where it initiated the first bulk delivery of mixed feeds. (Courtesy of the Sonoma County Library.)

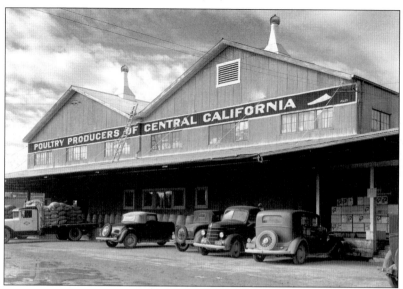

The Poultry Producers of Central California had a number of buildings, many still standing. The PPCC was a cooperative that established branches in Petaluma in 1916. Members from the region contracted with them to sell their eggs, delivering them to any one of 43 depots scattered about Petaluma. (Courtesy of the Library of Congress.)

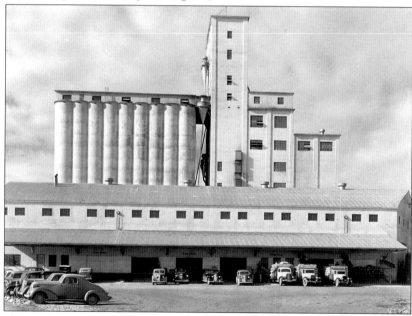

In 1938, the PPCC built what was considered the tallest building in the county for $500,000. The 11-story structure was erected by the Jones-Hettelsater Construction Company of Kansas City, Missouri. At the time of construction, a *Press Democrat* reporter stated that the "continued expansion of the Poultry Producers' business in Petaluma, Egg Basket of the World, and throughout central California has necessitated the huge new plant which will stand as a monument to progress of the Redwood Empire's richest agricultural county." This complex continues to be an important visual landmark in identifying Petaluma's past and present ties with agribusiness. (Courtesy of the Library of Congress.)

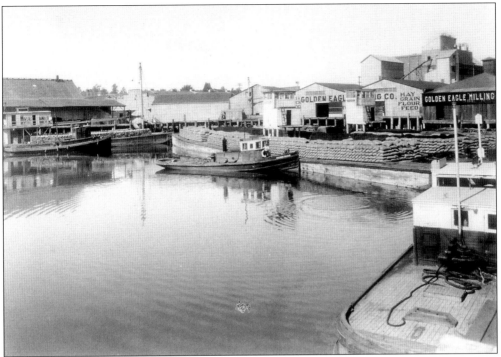

The Golden Eagle Milling Company, which was established in 1885 by the Percival brothers, was an important player in Petaluma's agriculturally based economy. In 1888, H. T. Fairbanks bought the mill and increased its size so that it covered six acres. By 1912, the mill was producing 250 barrels of flour and 25 tons of feed a day with the help of 60 employees. (Courtesy of the Sonoma County Library.)

The Golden Eagle Milling Company was demolished in 1965 and was replaced by the shopping center that bears its name on East Washington Street. (Courtesy of the Sonoma County Library.)

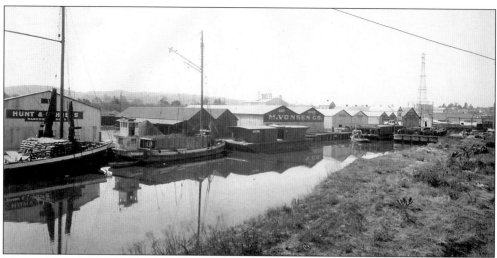

Magnus Vonsen was another important figure in the grain and feed business. In 1904, Vonsen formed a partnership with William J. Hickey and established a feed, grain, and grocery store on Kentucky Street. Hickey later left the partnership and Vonsen moved his business to the corner of Western Avenue and Keller Street (see page 33). Inventory for the store was kept in warehouses on First Street, where access to the river and eventually the Petaluma and Santa Rosa rail line made for a desirable location. For roughly 90 years, these simple repeating warehouse gables provided Petalumans with a visual link to its river and agriculturally based economy. In 2004, the buildings were torn down to make way for a commercial and residential development. (Courtesy of the Petaluma Museum.)

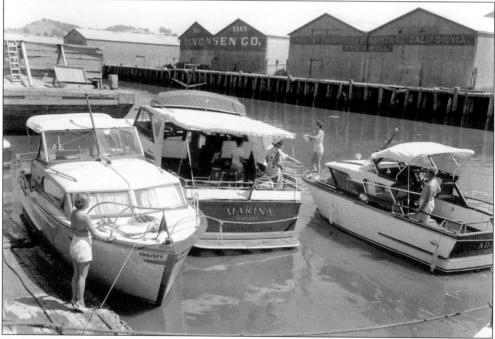

This 1950s view of the warehouses shows how the Petaluma River is used for both recreational and commercial purposes. The barge behind the motorboats is likely associated with the Jerico oyster shell plant. (Courtesy of the Petaluma Museum.)

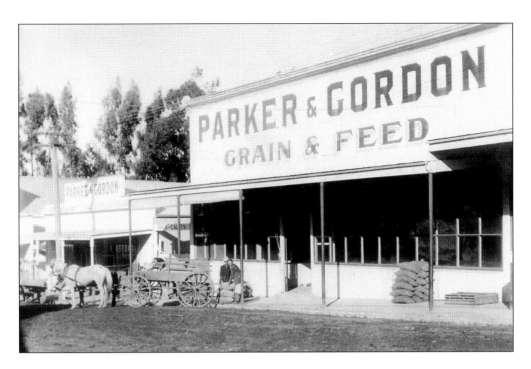

Parker & Gordon Grain & Feed, established in 1906 by James F. Parker and M. Herbert Gordon, also had an outlet at what is now 364–368 Petaluma Boulevard North. Prior to this partnership, Parker was in the hog and calf-buying business, which he had established in 1887. Ten years later, Gordon started his business career by purchasing eggs and later carrying a small stock of feed for his egg customers. In 1922, Parker retired and sold his interest to Gordon, who in turn retired in 1939 and sold the business to Albers Milling Company, which retained the name Parker and Gordon (shown below). This building is now used by Couches, Etc. for storage and is also occupied by a discount baby furniture store. (Courtesy of the Sonoma County Library.)

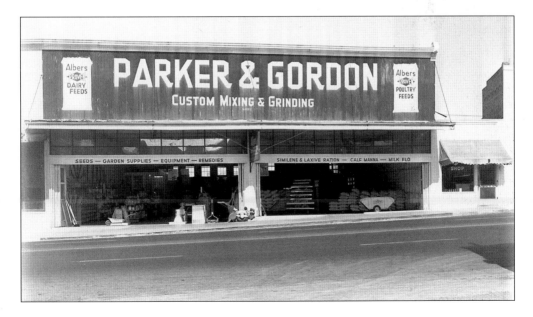

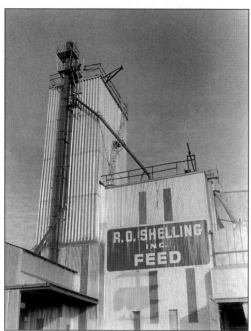

Rudolph Shelling established his feed and grain business in 1948 at the northwest corner of Magnolia Avenue and Petaluma Boulevard North. Shelling was born and educated in Germany and came to California in 1939, settling in Petaluma, which, at the time, still had the reputation as the "Egg Basket of the World." When Shelling died in 1985, his family expressed their commitment to carrying on with the feed and grain business. (Courtesy of the Sonoma County Library.)

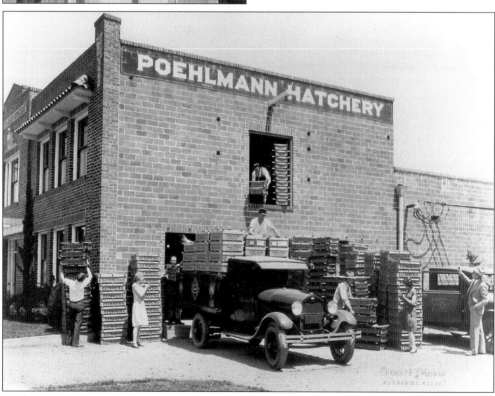

In close proximity to R. O. Shelling Company were several hatcheries of varying architectural styles. The number of these egg-related businesses stands as a testament to the impact that the poultry industry had on Petaluma's history. Pictured here is the Poehlmann Hatchery, located just a few blocks from the R. O. Shelling Company. (Courtesy of the Sonoma County Library.)

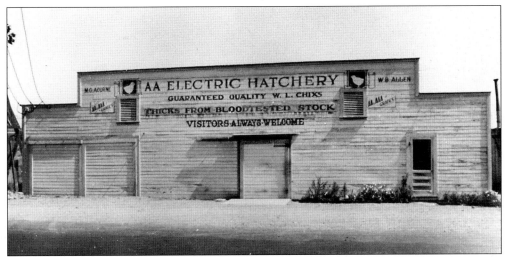

Melville G. (Curley) Acorne came to Petaluma in 1908 from Humboldt County. A man of many talents, he worked as a driver for a bakery, was employed by the Petaluma Silk Mill, the Corlis Engine Works, and the Pioneer Hatchery—all before entering World War I. Upon his return, Acorne managed the Merritt Ranch and then went to work for the Poehlmann Hatchery. In 1925, he became owner of the AA Electric Hatchery, pictured above, located at 1106 Petaluma Boulevard North, near Shasta Avenue.

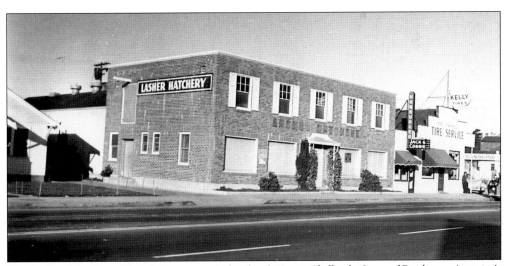

The Lasher Hatchery, Thea Lowry states in her book *Empty Shells, the Story of Petaluma, America's Chicken City*, was the first brick hatchery built in Petaluma, at 829 Petaluma Boulevard North. George Lasher constructed the building in 1917 after an earlier hatchery on the site burned down. (Courtesy of the Sonoma County Library.)

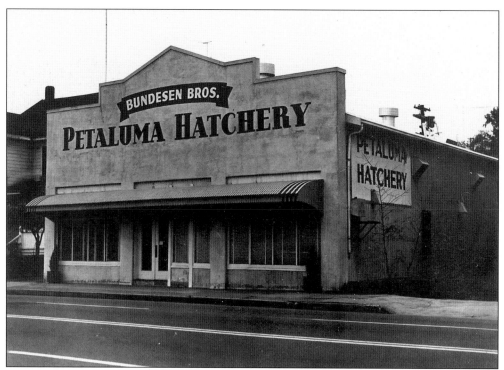

Bundesen Hatchery, now occupied by Redwood Glass, was established by brothers Herbert and Paul Bundesen. Recent graduates of CalPoly where they majored in poultry husbandry, the Bundesens purchased 619 Petaluma Boulevard North from Louis W. Clark in 1951. Mr. Clark had operated a hatchery at the site since 1902. The Bundesens later moved up the street to what had been the Hardin Hatchery. When that building was destroyed by fire, they relocated to the Petaluma Cooperative Hatchery on Bodega Avenue. (Courtesy of the Sonoma County Library.)

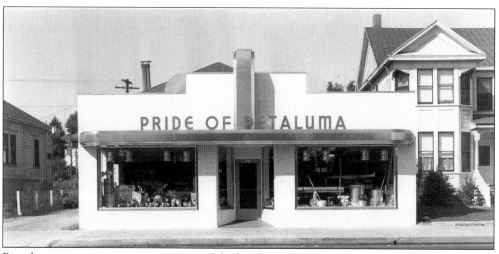

Brooder stoves were an important part of the hatching operation, and hatcheries relied on such businesses as the Pride of Petaluma, a brooder stove company once located at 615 Petaluma Boulevard North, where Tire Source is today. (Courtesy of the Sonoma County Library.)

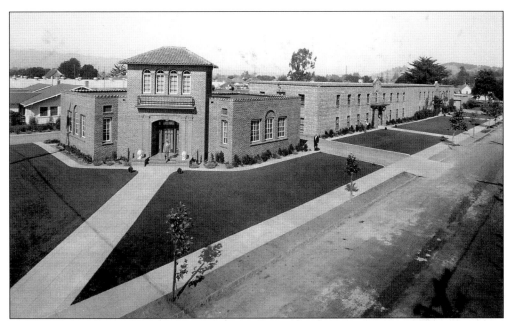

Brick was a typical building material used in the construction of hatcheries, as fire was always a concern. Some were grander than others. The Must Hatch Hatchery located at 401 Seventh Street is probably one of the more stylistic Petaluma hatchery buildings. The Must Hatch Hatchery was founded in 1898 by A. E. Bourke and burned down in 1923. Bourke hired Brainerd Jones to design a replacement, which was completed in 1927. A showplace during Petaluma's heyday, the Must Hatch Hatchery was the largest hatchery in the world in 1929. It was one city block long and reportedly turned out more than one and a half million chicks every three weeks. The company employed 500 people. (Courtesy of the Sonoma County Library.)

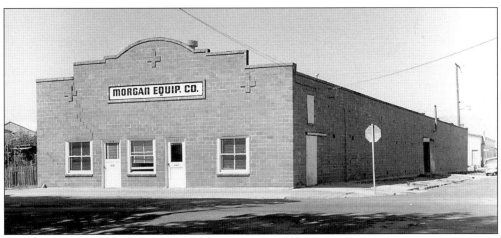

On a more modest scale was the Vestal Hatchery, owned at one point by Kenneth King, E. I. King, and Tom Vestal. This Mission Revival building is located at 519 Second Street. Since the 1960s, the building has been home to Morgan Manufacturing, whose products include auto body tools and tie-down equipment for the flatbed trucking industry. (Courtesy of the Sonoma County Library.)

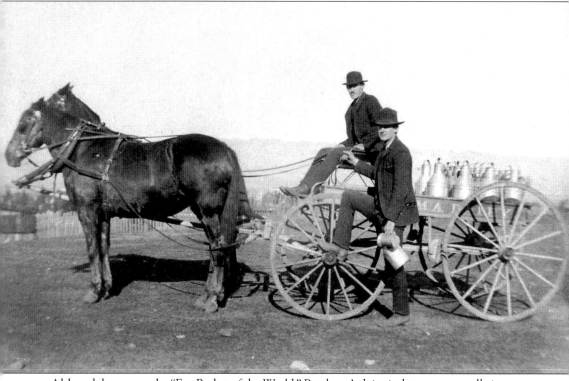

Although known as the "Egg Basket of the World," Petaluma's dairy industry was equally important to the economy of the town and continues to be so today. The 1860 Sonoma County livestock census showed a preponderance of dairy cows over beef cattle—5,350 to 3,588. Milch cows, as they were called, provided an important source of income. The cows were milked only from December or January until early June when the green feed disappeared, with the milk being home processed into butter and cheese for both local and commercial consumption. In April 1869, over 186,000 pounds of butter and 1,621 pounds of cheese were shipped out of Petaluma. During the 1870s, the dairy industry changed rapidly due to an influx of immigrants from the European dairying countries of Holland, Denmark, Switzerland, Germany, and Portugal. Attracted by accessibility to markets and the climate, these newcomers were immediately aware of Petaluma's advantages as a dairy center. By the 1880s, when supplemental feeding came into practice, Petaluma was the largest shipping point in the state for dairy products. (Courtesy of the Sonoma County Library.)

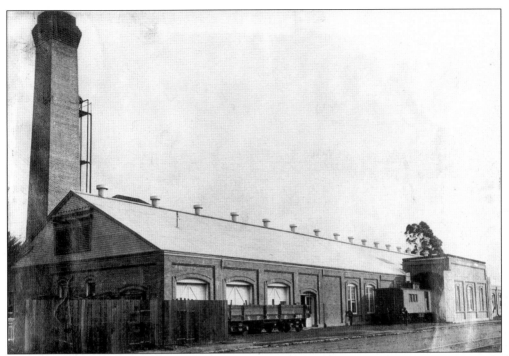

Facilities for the manufacturing and distribution of dairy products included the Burdell Creamery, established in 1898. Conveniently located across the street from the railroad depot, the creamery also served as a power plant and cold storage facility. (Courtesy of the Sonoma County Library.)

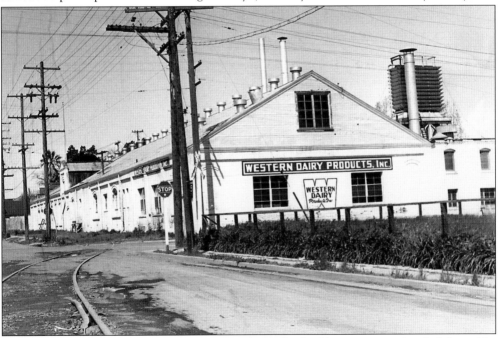

Shown here in the 1970s as Western Dairy Products, this building was recently rehabilitated by Creedence Construction Company and converted to a new use that includes a mixture of office and industrial spaces. (Courtesy of the Sonoma County Library.)

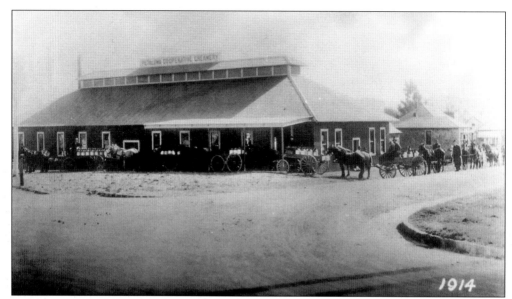

California's first dairy cooperative was formed in 1913 in Petaluma when Silvio Gambonini persuaded 32 fellow dairymen to join him in building a plant at the corner of Western Avenue and Baker Street and forming the Petaluma Cooperative Creamery. By pooling their resources, the farmers could build a state-of-the-art creamery where a steady supply of higher quality butter could be produced. In their first year of operation, six co-op employees churned cream from 1,900 cows and shipped out 200,000 pounds of butter. (Courtesy of the Sonoma County Library.)

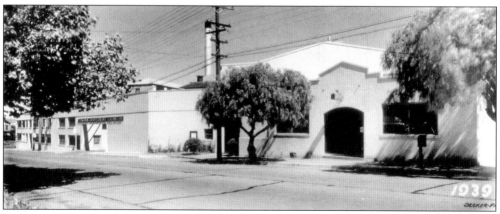

This is a 1939 view of the co-op. Today the plant takes up four acres, covering several blocks of Western Avenue, and is owned and operated by Spring Hill Jersey Cheese. (Courtesy of the Sonoma County Library.)

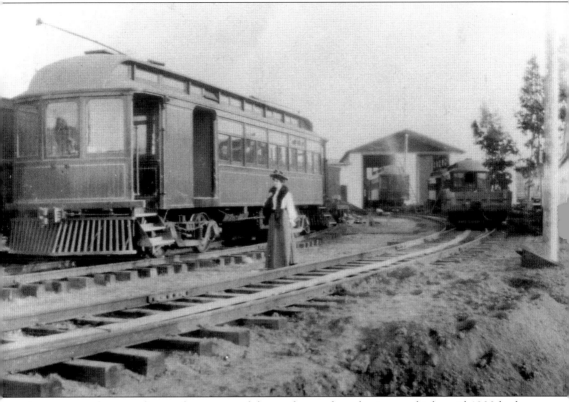

Access to markets was key to the success of the poultry and egg business, which until 1900 had been dependent on the Northwestern Pacific Railroad (previously known as the San Francisco and North Pacific Railroad) and the Petaluma River. In 1903, another means of getting products to and from Petaluma was established when the Petaluma and Santa Rosa Railway Company was incorporated. The P&SR was promoted chiefly by Petaluma grain dealer and real estate investor John A. McNear and the Spreckles Group of San Francisco, considered magnates of California's sugar industry. The P&SR purchased the paddle wheeler *Steamer Gold*, which had been traveling daily between Petaluma and San Francisco for years. The *Steamer Gold* was used for both passenger and freight. Products such as fruit and vegetables, eggs and poultry, and dairy products were picked up and brought to Petaluma during the day by rail and shipped to San Francisco via steamer at night. The P&SR's role in moving perishables earned it the nickname the "Chicken and Cow Line." The Northwestern Pacific bought the P&SR in 1932 at the same time that the automobile was significantly impacting the P&SR's passenger and freight traffic. (Courtesy of the Sonoma County Library.)

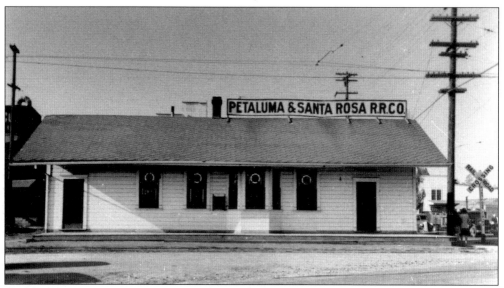

The Northwestern Pacific stopped all passenger service shortly after it purchased the P&SR. The only existing building associated with this important rail service was its former ticket booth, which was moved from Copeland and East Washington Streets to its current location at 226 Weller Street. (Courtesy of the Sonoma County Library.)

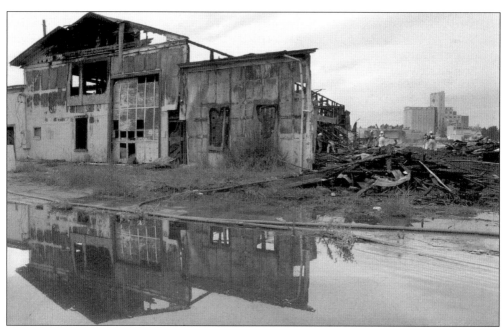

A September 2001 fire destroyed the train barns that housed the repair, machine, and paint shop of the P&SR located across the street on Weller and D Streets. (Courtesy of the *Press Democrat* and photographer Scott Manchester.)

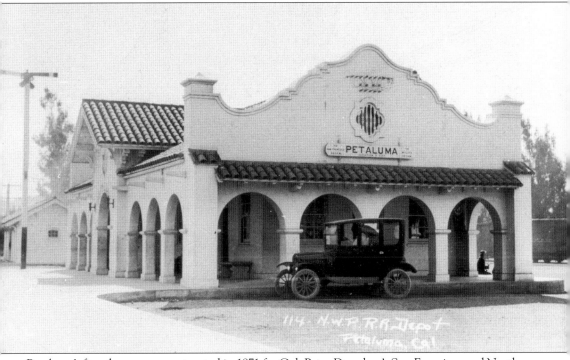

Petaluma's first depot was constructed in 1871 for Col. Peter Donahue's San Francisco and North Pacific Railroad. In 1914, this building was moved back (southwest) on the railroad property bound by Lakeville, East D, East Washington, and Copeland Streets and converted to a freight depot when the Northwestern Pacific Railroad built a new passenger depot and baggage department (shown above). Northwestern Pacific Railroad, whose parent company was Southern Pacific, hired local contractor H. P. Vogensen to construct these buildings. D. J. Patterson, a Southern Pacific staff architect, designed them in the Mission Revival style. The American Railway Express building located closest to East D Street was constructed in 1923 and also reflects the Mission Revival style. The "old" depot was demolished in 1947 following a fire. The old growth redwood that remained was salvaged and sold. (Courtesy of the Sonoma County Library.)

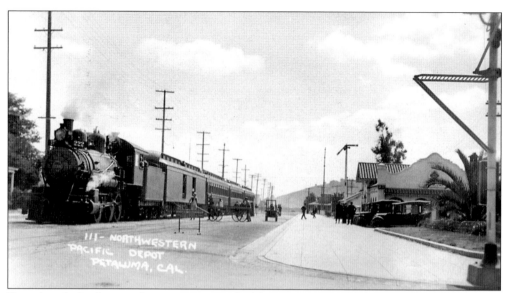

Even though the depot and its accompanying buildings' importance as the center of transportation declined rapidly in the 1930s with the growing popularity of automobiles and freight trucks, the significance of the buildings as symbolic of local history has been recognized by the current city council. The City of Petaluma is committed to seeing the building rehabilitated for eventual use by the Petaluma Visitors Bureau. The transportation-related use of the building might once again be realized, as a commuter rail system is being considered to link Marin and Sonoma Counties. (Courtesy of the Sonoma County Library.)

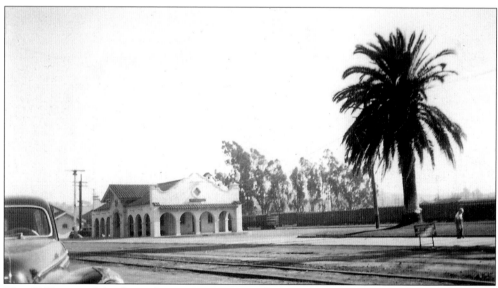

This 1945 view of the depot shows a prominent palm tree that once graced the site. Palm trees are a traditional railroad depot landscape feature. (Courtesy of Evelyn Lawson.)

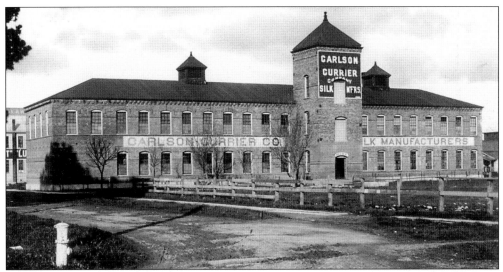

The Northwestern Pacific Railroad and the Petaluma and Santa Rosa Railroad were both located in what is commonly referred to as "Old East Petaluma," because it was east of the river. Many industrial and manufacturing plants such as the Carlson Currier Company, a silk manufacturer, were located here. Originally designed by Charles Havens, it was occupied by Carlson Currier Company from 1892 until 1917, when it was taken over by Belding-Heminway-Corticelli, which was replaced in 1940 by the current occupants, Sunset Line and Twine. The building is listed individually on the National Register of Historic Places. Buildings and businesses such as this prompted the chamber of commerce to proclaim Petaluma the "Lowell of the West" in a 1906 publication. (Courtesy of the Sonoma County Library.)

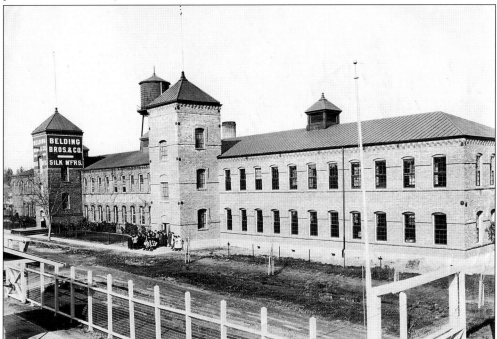

This photograph shows additions made in 1906 and 1922 to the Jefferson Street portion of the building designed by Brainerd Jones. (Courtesy of the Petaluma Museum.)

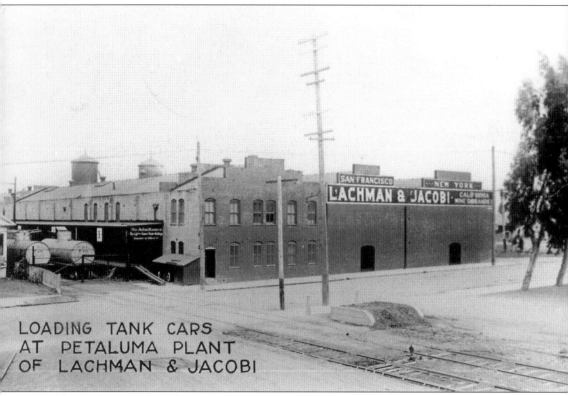

LOADING TANK CARS
AT PETALUMA PLANT
OF LACHMAN & JACOBI

The Lachman and Jacobi Winery, like several other manufacturing firms, moved to Petaluma from San Francisco following the 1906 earthquake and fire. The winery owned 10 acres of land adjoining the Northwestern Pacific on Lakeville Street and the Petaluma and Santa Rosa Railroad on Copeland in East Petaluma. The plant was located at 325 East Washington Street where Long's Shopping Center is today. The Lachman and Jacobi plant had a storage capacity of over four million gallons of wine and 500,000 gallons of brandy. Eight separate buildings were involved, the largest covering an area of 400 by 150 feet. Other structures included the U.S.-bonded warehouse, cooper shop, boiler house, and a tank building consisting of 18 reinforced, glass-lined cement tanks with an average capacity of 30,500 gallons each. During Prohibition, the plant was taken over by the National Ice Company. The buildings were torn down in 1973 and replaced by the current shopping center. During its planning stages, East Petaluma resident and historian Bill Soberanes described the center as "a new and unique complex somewhat similar to Ghirardelli Square in San Francisco." (Courtesy of the Sonoma County Library.)

Like the Lachman and Jacobi Winery, the Nolan-Earle Shoe Company was located in East Petaluma at the corner of Jefferson and Wilson Streets, behind the Carlson Currier silk mill. Annual sales for the company in 1907 was over half a million dollars. At the time, it produced 500 pairs of shoes a day and employed 100 workers, both men and women, many of whom lived in the surrounding residential neighborhoods. The building was demolished between 1960 and 1974. Seen below are workers of the Nolan-Earle Shoe Company, c. 1907 (Courtesy of the Sonoma County Library.)

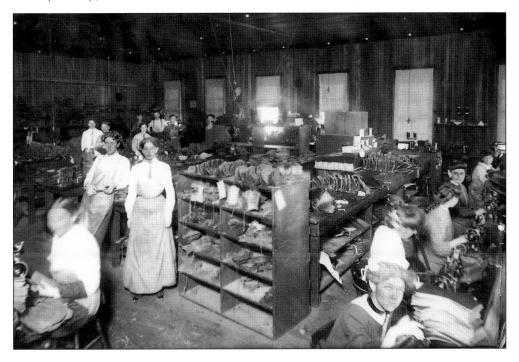

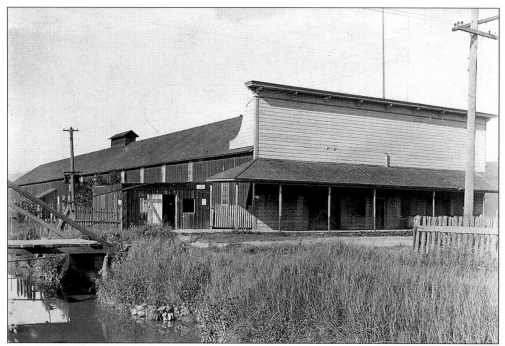

Another Petaluma manufacturing area called the Riverfront Warehouse District was located on the west side of the river, just opposite of the Old East Petaluma neighborhood. The Heynemann Overall Factory moved to the Riverfront Warehouse District from San Francisco in 1906 following the earthquake and fire. Taking over what had been the Petaluma Fruit Canning Company at 405 First Street, it became a major employer, primarily of women. In fact, the factory's presence created a need for additional housing that set off a building boom in the neighborhood. (Courtesy of the Petaluma Museum.)

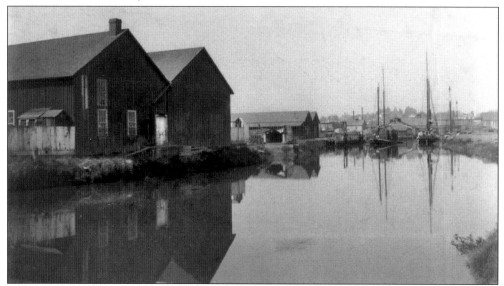

This view shows the river side of the wood-frame Heynemann Overall Factory, a gabled, board-and batten-sided building, looking north toward the D Street Bridge. (Courtesy of the Sonoma County Library.)

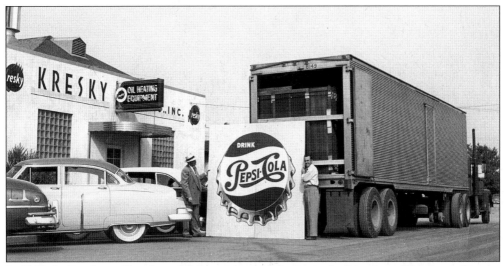

In 1907, the Petaluma Chamber of Commerce secured a site in the Riverfront Warehouse District at H and First Streets for the Corliss Gas Engine Company, which wanted to relocate from San Francisco. By 1911, the company had expanded and demand for employee housing became an issue. On July 7, 1911, the *Argus Courier* ran a story describing how 10 families needed housing that ranged in size from four to six rooms and rented for $12 to $15 per month. In 1945, Kresky Manufacturing purchased the Corliss Gas Engine Company plant. Today the property is known as Foundry Wharf and consists of a combination of new construction with adaptively reused historic buildings. This photograph features one of the buildings on the Second Street side of the complex, which still exists. (Courtesy of the Petaluma Museum.)

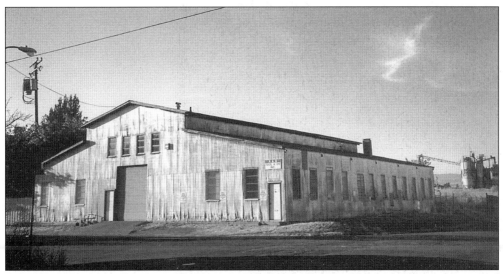

Adjacent to Foundry Wharf at 521 First Street is the former Stayner Foundry building, constructed by local contractor H. S. McCargar in 1912. The building was later purchased by the City of Petaluma, who used it to store street machinery and tools. A&G Tool and Die now occupies the building. The word "Foundry" is just barely visible on the river side of the building, indicating its past use. (Photograph by Katherine J. Rinehart.)

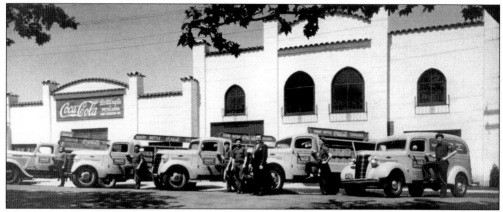

The former 1937 Coca-Cola Bottling Plant, which replaced its predecessor, the Petaluma Soda and Selzer Works, is located in the Riverfront Warehouse District at the northwest corner of G and Second Streets. Arnold Jensen managed the plant which, at the time of its construction, was one of the largest industrial plants in the community. Although an industrial building, the Mission Revival style demonstrates that a building used for manufacturing purposes need not lack detail. (Courtesy of the *Argus Courier*.)

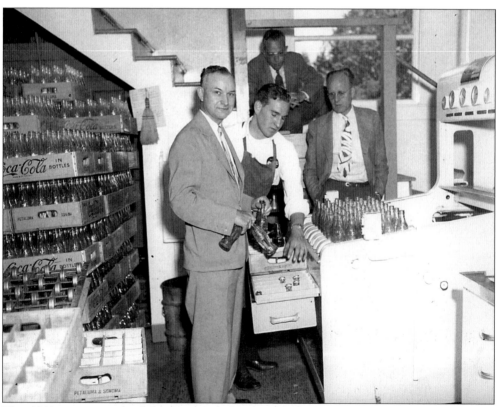

This 1940s interior view of the Coca-Cola Bottling Plant shows visiting chemists conducting inspections with the help of young plant employee Ernie Fadelli, in the apron. (Courtesy of the Sonoma County Library.)

# *Four*

# PUBLIC BUILDINGS

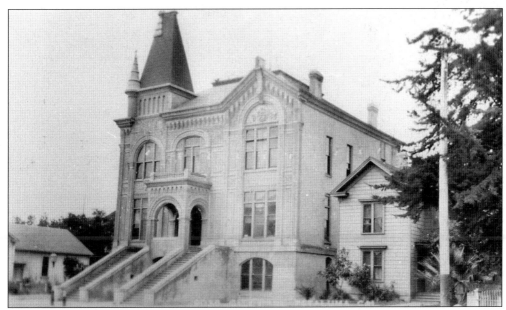

A city's character is often defined by its architecture, especially its public buildings, which reflect the values and taste of the community. (Courtesy of the Sonoma County Library.)

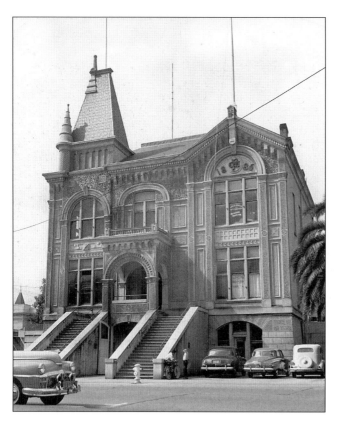

One of Petaluma's most architecturally significant buildings was its city hall. Designed by Samuel and Joseph Cather Newsom of San Francisco, the building was constructed by George Furner, whose bid of $15,499 was accepted on August 11, 1886. This ornate stone building was demolished and replaced by a parking lot in 1955. (Courtesy of the Petaluma Museum.)

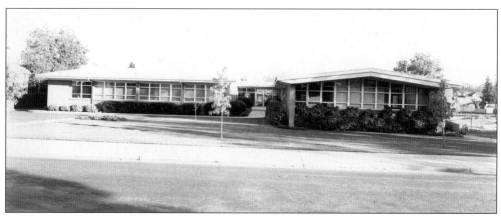

Petaluma's new city hall was designed by J. Clarence Felciano and constructed by B and R Construction on English Street on a site purchased from the Petaluma School District for $20,000. Building the city hall called for the demolition of the existing Washington Grammar School and razing or relocating a number of houses on Post Street between English and Bassett Streets. (Courtesy of the Sonoma County Library.)

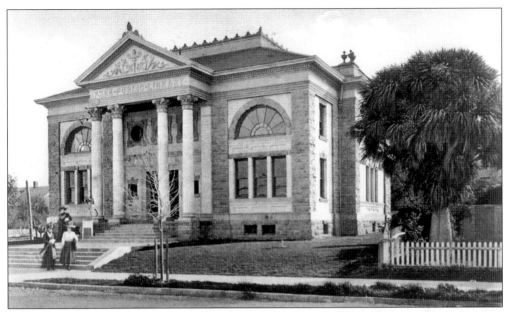

What is known today as the Petaluma Historical Museum at 20 Fourth Street was originally a Carnegie Free Library. The cornerstone was laid in 1904, and the library officially opened in 1906. This neoclassical building was designed by Brainerd Jones and built by R. W. Moller and William S. Stradling with locally quarried sandstone from Stony Point. The building is individually listed on the National Register of Historic Places. (Courtesy of the Sonoma County Library.)

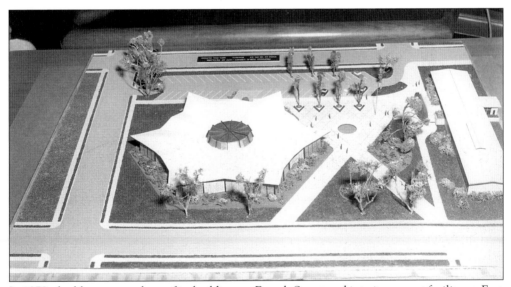

In 1978, the library moved out of its building on Fourth Street and into its current facility on East Washington Street. Pictured here is Santa Rosa architects Steele and Van Dyke's vision of the new library. This design apparently was not approved as it was never built. Dick Lieb designed the building known today as the Petaluma Library. (Courtesy of the Sonoma County Library.)

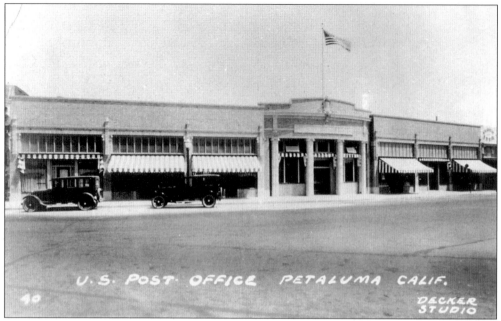

In 1926, George P. McNear hired Brainerd Jones to design and H. P. Vogensen to construct what would be Petaluma's second post office. The building combines neoclassical elements in the entrance with Gothic Revival–style detailing at the columns. (Courtesy of the Sonoma County Library.)

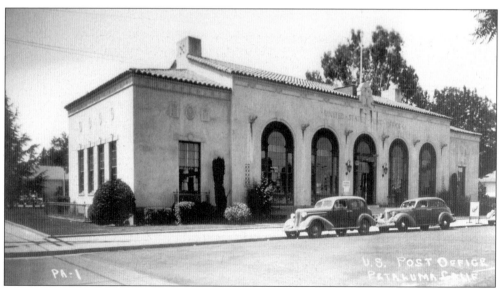

In 1932, the post office moved to a new building on Fourth Street that was designed in the Spanish Colonial Revival style by James Wetmore, supervising architect for the U.S. Department of the Treasury. (Courtesy of the Sonoma County Library.)

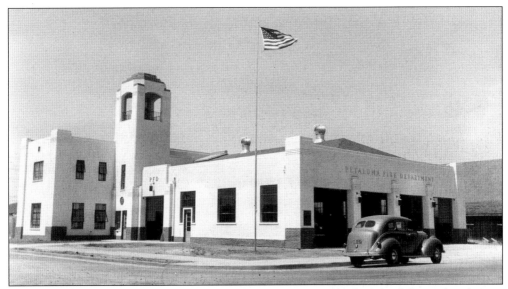

Brainerd Jones designed this art deco fire station in 1938. It was built on land donated to the city by George P. McNear in 1926. A grant from the Public Works Administration made construction possible. According to *Public Buildings: Architecture Under the Public Works Administration, 1933–1939* (volume 1), the construction cost was $39,403 and the project cost was $43,858 for this building. An addition to the Second Street side of the fire station was designed and completed by Dick Lieb in 1970. (Courtesy of the Sonoma County Library.)

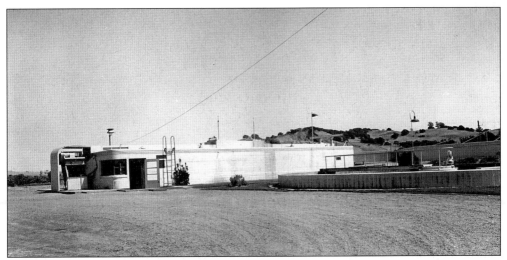

Also in 1938, a PWA grant was used to build a sewage treatment plant. Harry N. Jenks, a pioneer in the sanitary engineering field, designed the plant. The boiler room, pictured here, is an example of the Streamline-Moderne style. (Courtesy of the Petaluma Museum.)

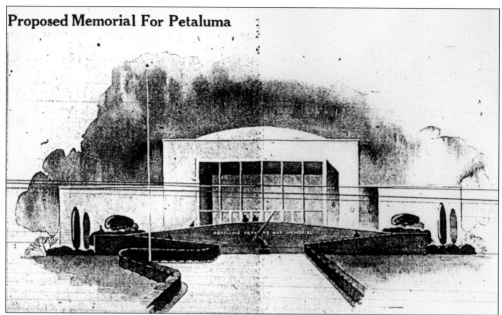

**Proposed Memorial For Petaluma**

This December 5, 1949, sketch of a proposed Petaluma Veterans Memorial showed a two-story building that was estimated to cost $320,000 to construct. (Courtesy of the *Argus Courier*.)

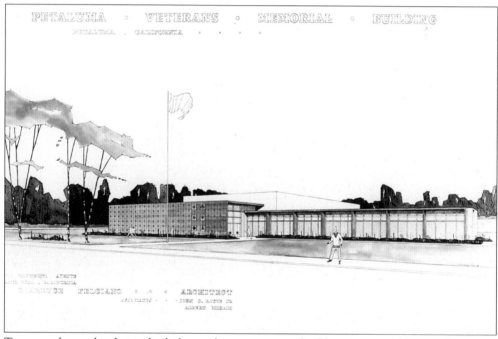

Ten years later, the design had changed to a one-story building estimated to cost $394,490. J. Clarence Felciano drew both designs. The second design was accepted, and the completed building was dedicated on April 19, 1959. The two designs provide an interesting contrast between 1940s and 1950s architectural styles. (Courtesy of the Sonoma County Library.)

# *Five*

# SCHOOLS

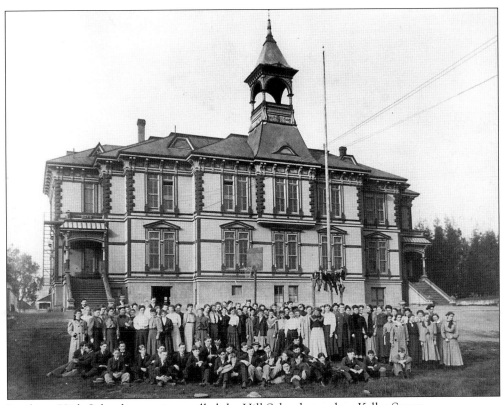

Petaluma High School, sometimes called the Hill School, stood on Keller Street.

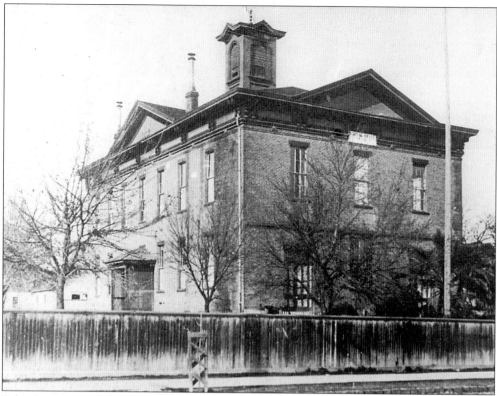

Schools are one of the major identifying characteristics of a town and an integral part of the residential landscape. Petaluma's first school was built in 1858 on B Street and is reported to have been the first brick schoolhouse constructed in Sonoma County. (Courtesy of the Sonoma County Library.)

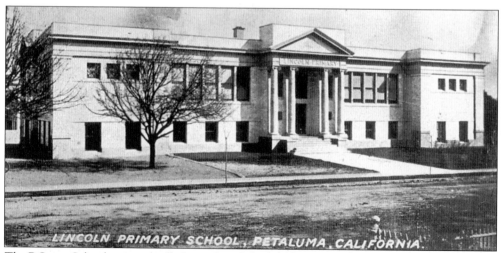

The B Street School, as it was called, was demolished in 1911 and replaced by the Lincoln Primary School, also constructed of brick. The Lincoln Primary School was designed by Brainerd Jones in a neoclassical style. Within the last few years, the building has been converted to accommodate office space. (Courtesy of the Sonoma County Library.)

In 1868, Prof. E. S. Lippitt constructed a private academy on D Street, which was purchased in 1873 by the board of education for use as Petaluma's first high school. The building was demolished in the 1920s and replaced with what many residents remember as the Tomasini residence at 625 D Street. (Courtesy of the Sonoma County Library.)

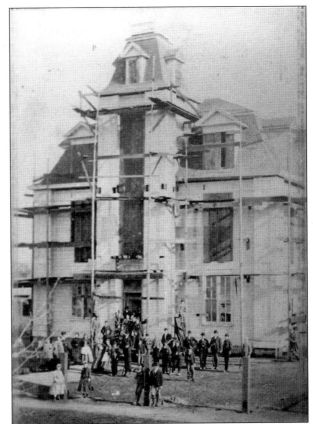

Petaluma's second high school was built in 1889. It was located on Keller Street between Oak and Walnut Streets on the current site of the Philip Sweed School. (Courtesy of the Sonoma County Library.)

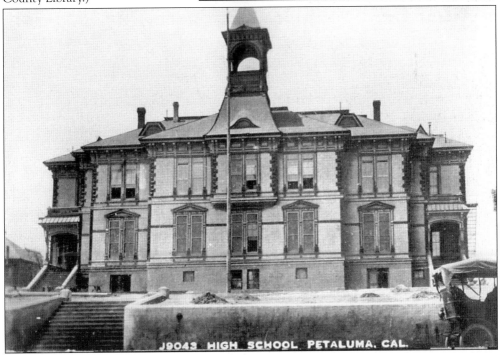

J9043 HIGH SCHOOL, PETALUMA, CAL.

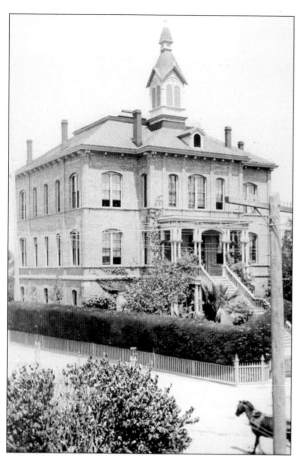

The St. Vincent's Academy at 246 Howard Street was designed by Thomas J. Welsh and built in 1888. The building served as both a school and convent until 1916, when a separate convent was constructed. (Courtesy of the Sonoma County Library.)

In 1937, the top floor of the academy was removed after condemnation by the fire department. In that same year, a new elementary school, shown here, was built on the property, and the academy was used by the upper grades only. In 1989, the building was condemned again following the Loma Prieta earthquake. Work to restore this building, the convent, and the 1937 elementary school is currently underway. (Courtesy of the Sonoma County Library.)

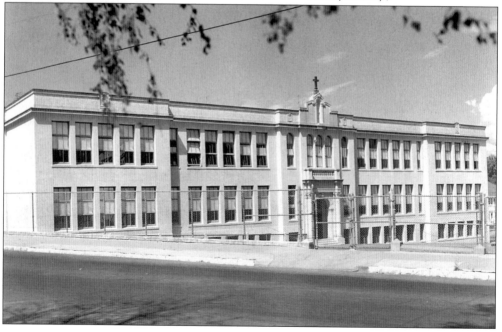

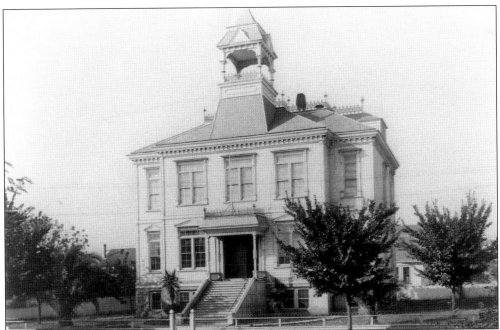

Pepper Kindergarten, completed in 1894, was Petaluma's only endowed school and its first kindergarten. W. H. Pepper, a wealthy nurseryman, donated the site, provided $5,000 for construction, and $15,000 to be invested, the interest paying the cost of maintaining the building. (Courtesy of the Sonoma County Library.)

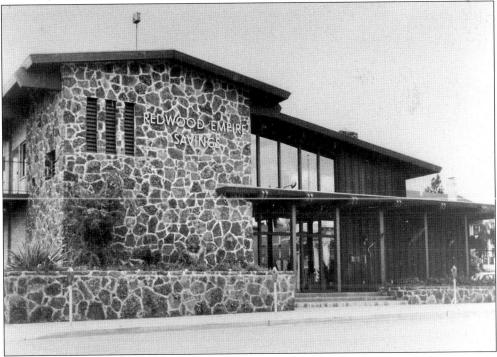

Pepper Kindergarten was torn down in the 1960s, and a bank, shown here, was built on the site. (Courtesy of the Sonoma County Library.)

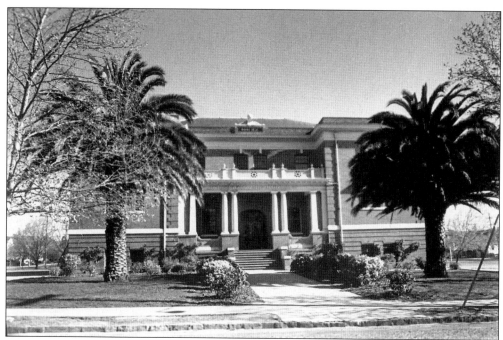

Washington Grammar School, designed by Louis Stone and Henry Smith of San Francisco, was built in 1905 on Post Street, between Bassett and English Streets, thanks to a $35,000 school bond. The contractor was R. W. Moller. Until that time, the property had been known as the Bassett Street Plaza, which for years had been the subject of much dissatisfaction to townspeople. They complained that the place was "a dismal swamp, used too frequently as a receptacle for garbage and all sorts of refuse matter which people find it convenient to dump somewhere." (Courtesy of the Sonoma County Library.)

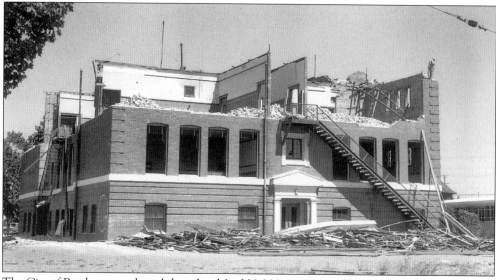

The City of Petaluma purchased the school for $20,000 in 1950, and later demolished it. City hall is just barely visible at the far right of this photograph. (Courtesy of the Petaluma Museum.)

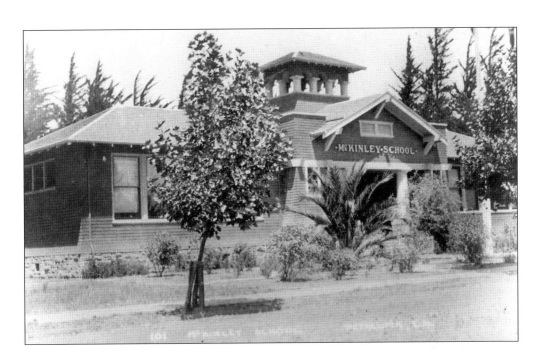

The McKinley School, pictured above, was built in 1911 by local contractor Frederick Cullen, at the corner of East Washington and Vallejo Streets, replacing the one-room Washington Street School. Brainerd Jones designed the McKinley School in the Craftsman style. The school served students of Old East Petaluma until the 1950s, when it was torn down and replaced by a shopping center. The new McKinley School on Ellis Street, seen below, designed by architects Stanton and Phillips of Pacific Grove, opened in 1950. (Courtesy of the Sonoma County Library.)

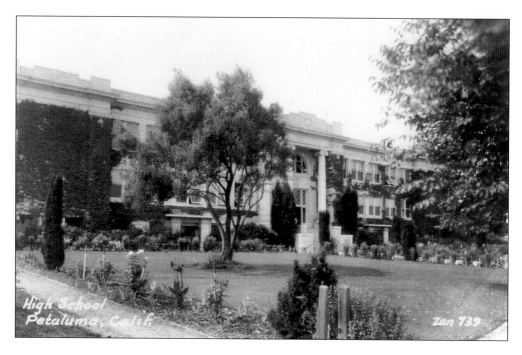

Brainerd Jones designed Petaluma's third high school in 1915. Located on Fair Street, this school, pictured above, was razed in 1958 and replaced by a new building designed by Malcolm Reynolds. In order to receive state funding to build the new high school, the city was required to close Bassett Street between Fair and Broadway. A number of houses on Fair and Webster Street were removed to facilitate construction. The photograph below shows the new high school under construction. (Courtesy of the Sonoma County Library.)

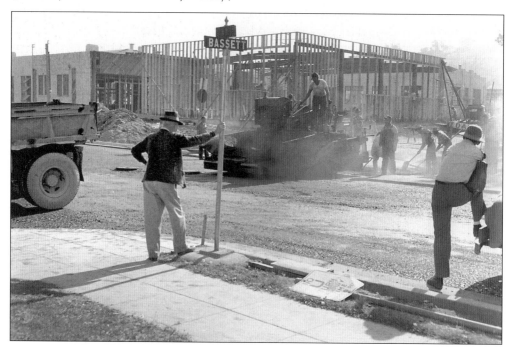

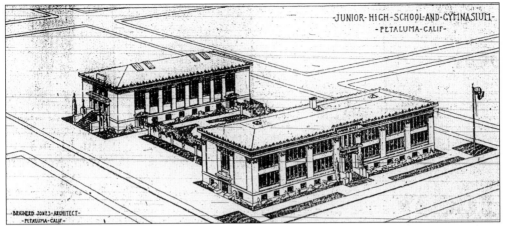

In 1922, Brainerd Jones designed yet another school building, the Petaluma Junior High and gymnasium. These buildings were located on Fair Street between English and Bassett Streets. Ward and Jones of San Francisco were the contractors, having submitted a bid of $178,890 for the main building and $1,385 for the brick walls of the gymnasium. (Courtesy of the *Argus Courier*.)

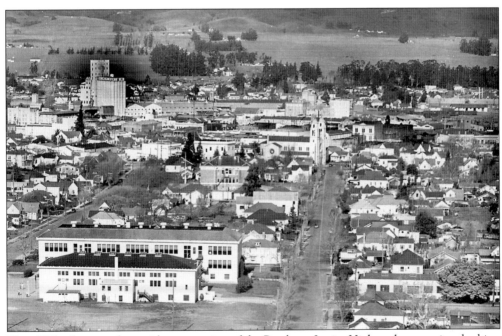

This 1930s photograph provides a rear view of the Petaluma Junior High and gymnasium looking from the hills to the west of the school. These buildings were torn down in 1958 when the new high school was constructed. Note that Bassett Street at Fair Street is still open. (Courtesy of the Sonoma County Library.)

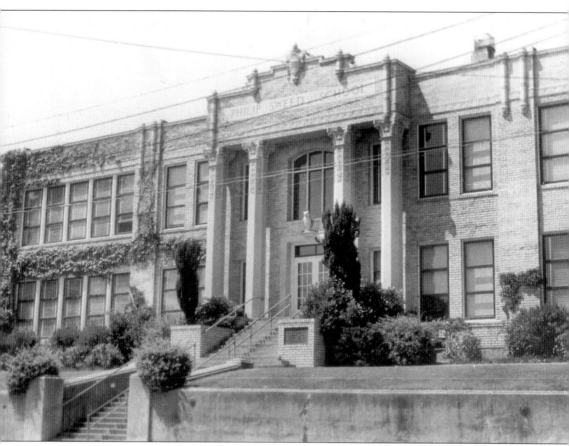

Brainerd Jones also designed the Philip Sweed School at 331 Keller Street. Philip Sweed, a Bavarian who arrived in Petaluma in 1876, was a merchant and very active in the community. His most distinguished service was as president of the board of education from 1893 to 1925. In recognition of his service, the board named its new school on Keller Street after him in 1927. The building is constructed of reinforced concrete and clad in buff-colored brick with beige terra-cotta tile detailing. Architecturally, the building is a classically inspired design with symmetrical massing. The entry is framed by two pairs of monumental, octagonal columns below a projecting, stepped parapet. Plans to reuse this building after many years of neglect are underway. The plan calls for conversion to residential use, with new housing units to be built on the Liberty Street side of the property. A great deal of time has gone into assuring that the design and quality of materials are consistent with the existing historic school and neighborhood, which are part of the Oakhill Brewster Historic District. (Courtesy of the Sonoma County Library.)

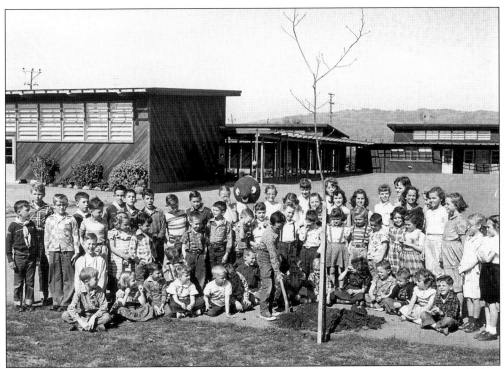

The 1950s were an active time in Petaluma for school construction. The McNear School on Sunnyslope Avenue, shown here, was completed in 1951. (Courtesy of the Sonoma County Library.)

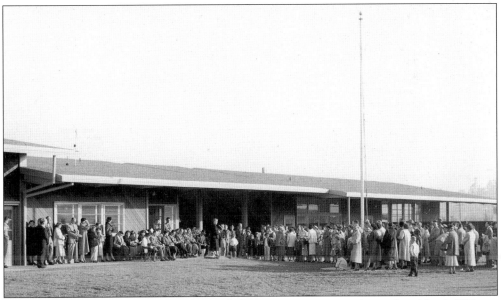

Valley Vista School, pictured here during dedication ceremonies, is located on North Webster Street and opened in the fall of 1954. Like much of the architecture of this era, these simple buildings are in sharp contrast to the ornate brick educational institutions of the early 20th century. (Courtesy of the Sonoma County Library.)

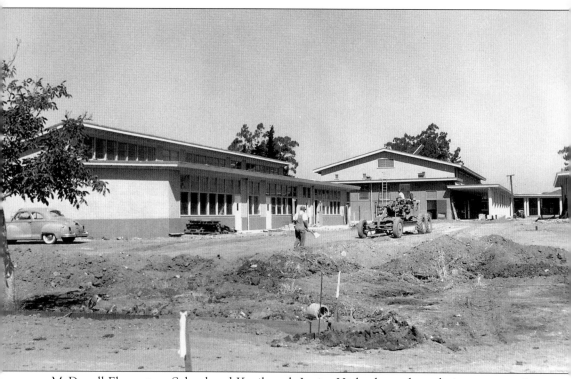

McDowell Elementary School and Kenilworth Junior High, shown here during construction, were completed in 1957. Kenilworth Junior High was named after a racehorse that was owned by Harry Stover. The school sits on what used to be a 100-acre fairground that included a racetrack, established in 1881. Kenilworth ran at this track, and later the fairgrounds themselves were named Kenilworth Park. The Petaluma School District recently sold the Kenilworth Junior High School property, which included not only the building but also 37 acres of land, to a development company that plans to build a shopping center on the site. A new Kenilworth Junior High, designed by Quattrocchi Kwok of Santa Rosa, is being built on Reisling Road. The $25.4 million facility is expected to be open in fall 2005. (Courtesy of the Sonoma County Library.)

# Six

# PLACES OF WORSHIP

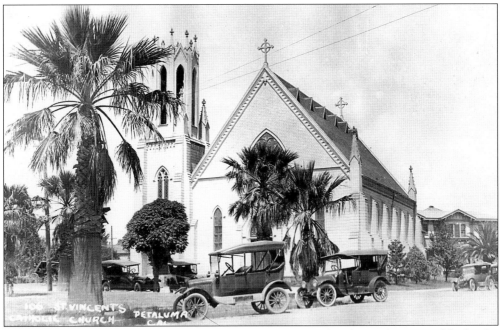

Petaluma has no shortage of religious architecture associated with a wide range of faiths. St. Vincent's, the Roman Catholic church featured in this photograph, is just one of many. Interestingly, this vernacular Gothic wood-frame church was later moved and occupied by members of the Elim Lutheran congregation. (Courtesy of the Petaluma Museum.)

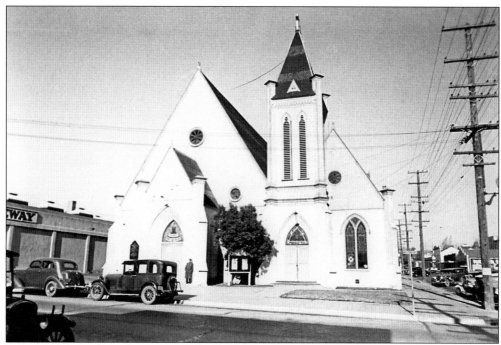

The Methodist Episcopal congregation organized in 1851, and in 1856 erected a church in Petaluma, on Fourth Street. This building was replaced by a new church, shown above, that was designed in the Gothic style and constructed between 1865 and 1874 at the northwest corner of Keller Street and Western Avenue, where the parking lot for the Petaluma Market is today. (Courtesy of the Sonoma County Library.)

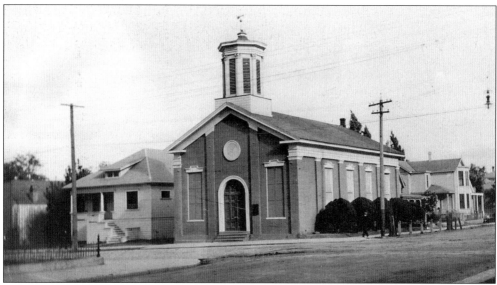

In 1860, the Methodist Episcopal Church, South, who had separated from the Methodist Episcopal Church in the 1840s over the issue of slavery, built a church at the southeast corner of Liberty Street and Western Avenue, where Plum Tuckered is currently located. This Greek Revival brick church had a seating capacity of 250. (Courtesy of the Sonoma County Library.)

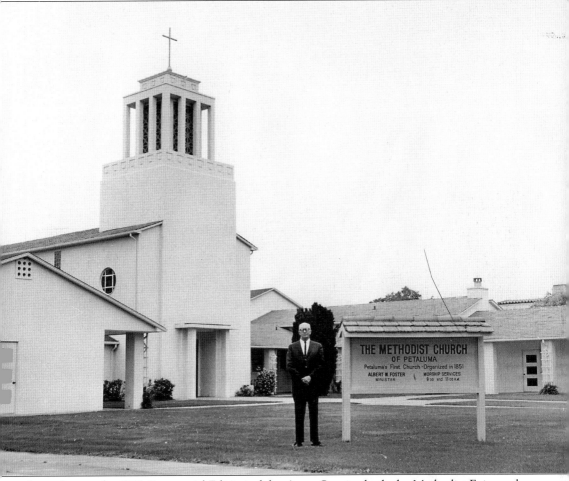

According to the 1955 Centennial Edition of the *Argus Courier,* both the Methodist Episcopal and the Methodist Church South merged in 1925–1926. The Methodist Episcopal congregation bought the Methodist Church South property, as both buildings were needed. In 1939, three Methodist denominations united—the Methodist Episcopal, Methodist Episcopal South, and Protestant Methodist, and in 1941, the United Methodist Church was erected at the northeast corner of D and Fifth Streets on property that was once part of the John A. McNear Sr. homestead. Vincent G. Raney was the supervising architect. Raney spoke to the Methodist Men's Club prior to completion and stated that the structure was going to leave "a record for future generations to read, as to how we worship and study and learn to live in our lives as free Christian citizens." (Courtesy of the Sonoma County Library.)

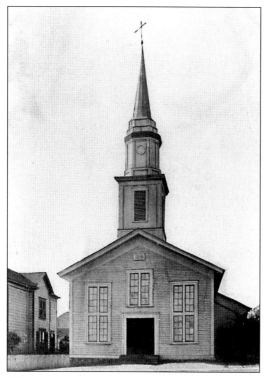

The First Baptist Church of Petaluma is the second oldest church in Petaluma, built in 1857 on Kentucky Street. This original, wood-framed church was replaced in 1911 by a brick neoclassical building designed by Brainerd Jones and constructed by H. P. Vogensen. This building, seen below, was torn down in 1964 when a new church was built on North Webster Street. The stained glass windows from the 1911 church were installed in the new church. (Courtesy of the Sonoma County Library.)

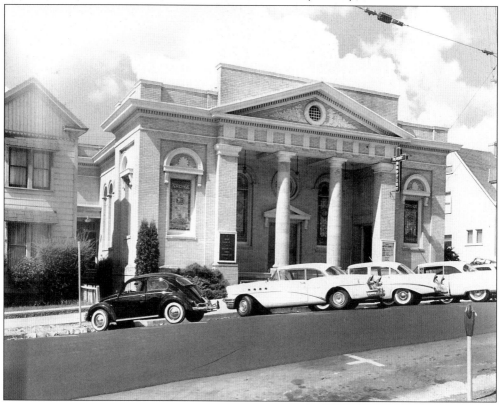

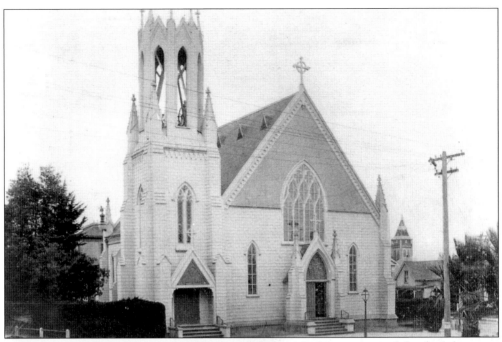

St. Vincent's parish has had three churches. The first was built in 1857 on Keokuk and Prospect Streets. The second church, completed in 1876, was constructed of wood and designed in the Gothic style. Located at the current site of St. Vincent's at Liberty and Bassett Streets, shown here, the church was moved in 1925 to the corner of Baker Street and Western Avenue and is now Elim Lutheran Church. (Courtesy of the Sonoma County Library.)

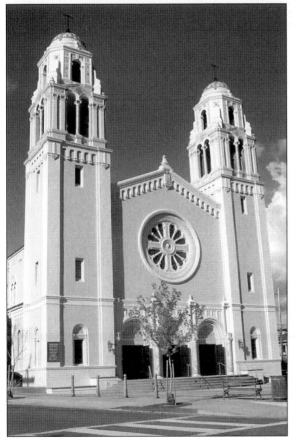

In 1926, the present St. Vincent's Church was completed in the Spanish Colonial Revival style at a cost of approximately $160,000, including furnishings. Leo J. Devlin of San Francisco was the architect. (Photograph by Gloria Campau.)

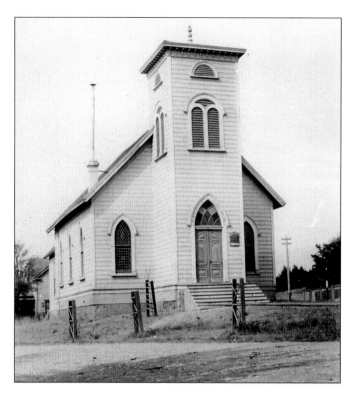

The Christian Church of Petaluma erected their first church, a vernacular wood-framed Gothic Revival style, in 1885 on Western Avenue. In 1911, this church was replaced by a new building, shown below. An example of the shingle style, this church possesses an irregular, steeply pitched roofline, and asymmetrical facade, and integrated turret, and shingled exterior. (Courtesy of the Sonoma County Library.)

The City of Petaluma purchased this building for $22,500 in 1971 and in 1972 proposed to raze it to make way for a parking lot. Urged by the newly formed preservation group, Heritage Homes of Petaluma, and others, the city gave up its plan for demolition. Heritage Homes provided a new roof for the building. In 1994, the building was renamed the Polly Hanna Klaas Memorial Performing Arts Center. Today this city-owned and maintained building is used only for storage and is in desperate need of rehabilitation. (Courtesy of the Sonoma County Library.)

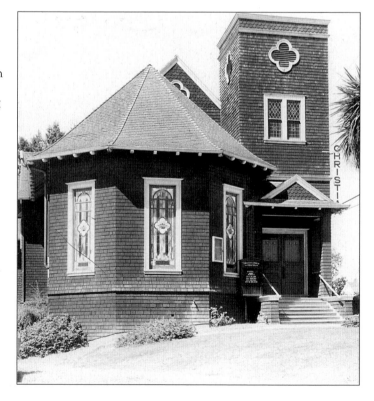

The Presbyterians held services in their new church on Fourth Street in February 1885. Once located next door to the Petaluma Museum, this church was torn down in 1963 when a new church, seen below, was constructed on B Street. Fortunately, the original stained-glass windows, including five memorial windows, were saved and have been in storage for the past 42 years. Plans are in progress to restore these beautiful windows and find a place where the public can view them—possibly in the church on B Street. (Courtesy of the Sonoma County Library.)

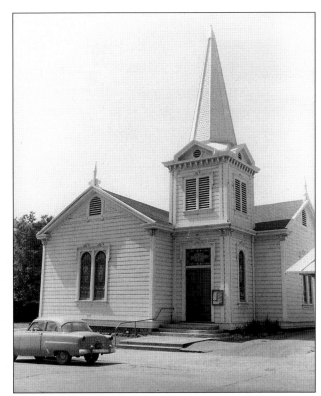

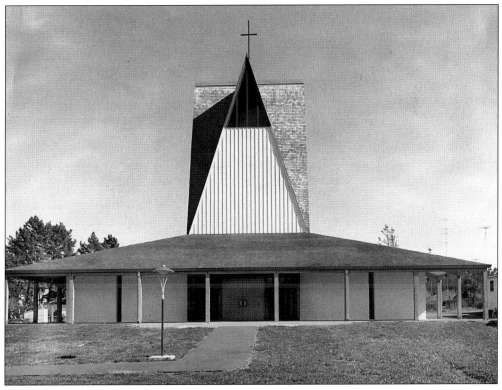

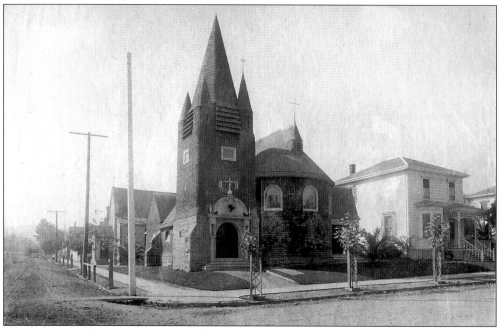

Ernest A. Coxhead, an important San Francisco architect, designed St. John's Episcopal Church in 1890. Architectural historian Marianne Hurley describes the building as one of Coxhead's most successful shingle-styled churches. Both the exterior and interior exhibit his inventive manipulation of classical and medieval design precedents. English Queen Anne. Note the use of stone at the base of this church, which is similar to that used on the former Carnegie Library. (Courtesy of the Petaluma Museum.)

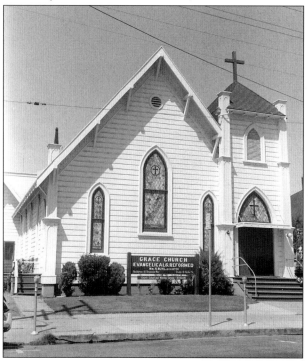

Also built in the 1890s is the former Grace Evangelical Church on Keller Street, which has a more Gothic appearance. In addition to serving as a church, this building has housed the Petaluma Cafe and Alfred's Steak House. In 1997, it was renovated to its current use as law offices. (Courtesy of the Sonoma County Library.)

The First Congregational Church on Fifth and B Streets was designed by Brainerd Jones and built by the contracting firm of Rodd and Rodd in 1901. This building replaced an earlier church on the property. Two memorial windows were taken out of the old church and installed in the new church. (Courtesy of the Sonoma County Library.)

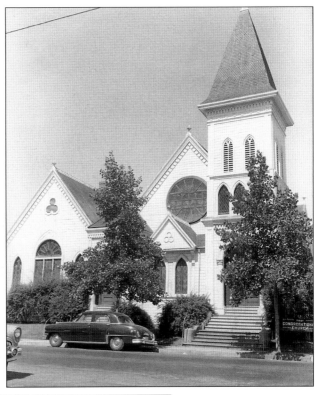

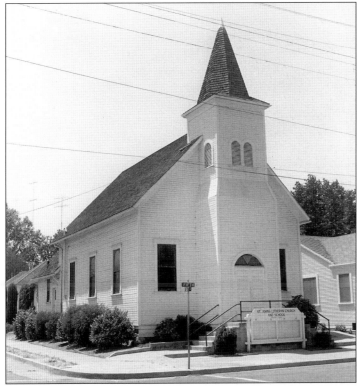

The modest St. John's Lutheran Church on Fifth and F Streets was built in 1911. It now serves as a private residence. (Courtesy of the Sonoma County Library.)

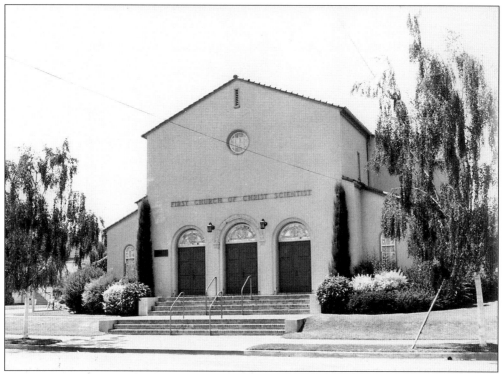

The Spanish Colonial Revival First Church of Christ, Scientist was designed by Edward C. Bolles, a San Francisco architect, in 1922. Distinctive features of this building are its caramel and white leaded-glass windows composed of alternating motifs of circles and diamonds. (Courtesy of the Sonoma County Library.)

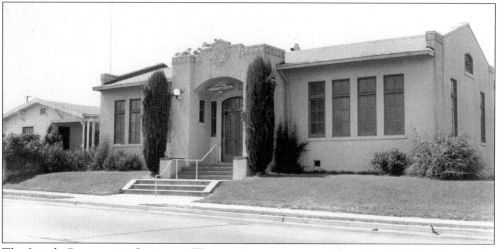

The Jewish Community Center on Western Avenue was completed in 1925. Funding for its construction came from members of the community and from Mrs. Abraham Haas of San Francisco, who donated $5,000. In addition to serving as a community center, the building includes a synagogue. (Courtesy of the Sonoma County Library.)

# Seven

# CLUBS, RECREATION, AND ENTERTAINMENT

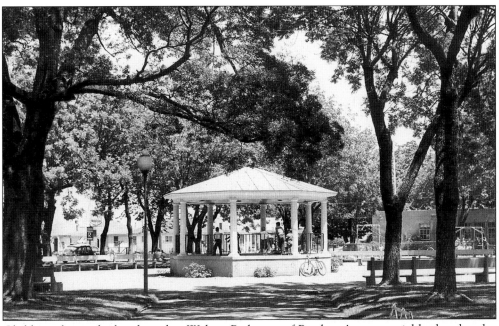

Children play at the bandstand at Walnut Park, one of Petaluma's many neighborhood parks. Originally known as D Street Plaza, this park's first 100 walnut trees were planted in 1886. It was once enclosed by a low picket fence and had a tank house and windmill. The bandstand was dedicated in 1927 as the first community project undertaken by the local Lions Club. The bandstand is one of numerous structures associated with Petaluma leisure activities. (Courtesy of the Petaluma Museum.)

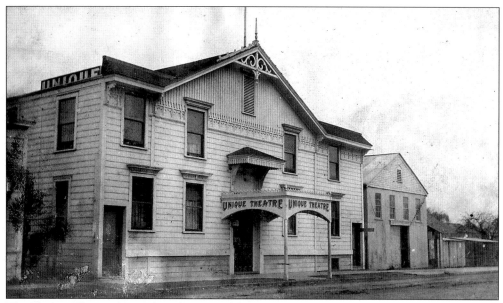

The Unique Theatre, located on the east side of Fourth Street between B and C Streets, was one of Petaluma's foremost entertainment spots. In later years, it was the town's skating rink until Dreamland became the premier skating spot. The Unique Theatre was demolished in 1966. (Courtesy of the Petaluma Museum.)

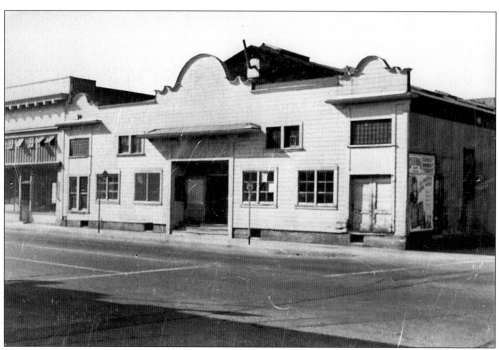

Dreamland Skating Rink was a wood-frame building with a Mission Revival false front designed by Brainerd Jones and built in 1906. It stood on what is now the northeast corner of Petaluma Boulevard and C Street, where Boulevard Cinemas is located. Petaluma Laundry, no longer standing, is shown here to the left of Dreamland. (Courtesy of the Sonoma County Library.)

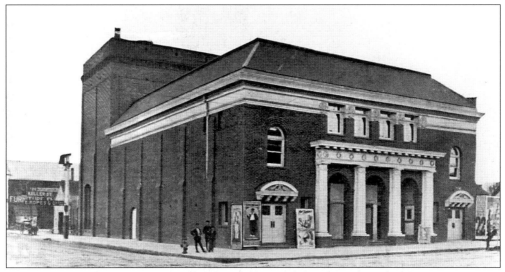

William H. Toepke, a San Francisco architect, designed the original Petaluma Opera House on Washington Street for Mrs. Josie Hill and her son, A. B. Hill, in 1904. Hinson and Sons of San Francisco were the contractors, and N. L. Nagle of Santa Rosa did the brickwork. (Courtesy of the Sonoma County Library.)

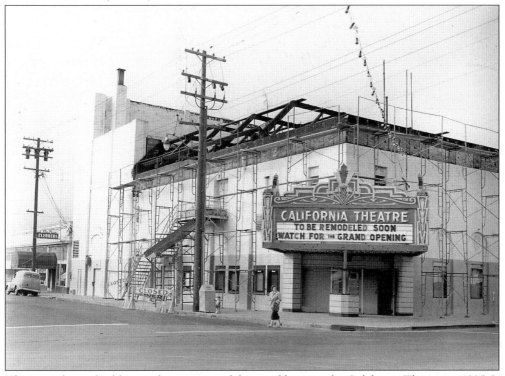

The opera house building underwent remodeling and became the California Theatre in 1925. It was here, on February 13, 1932, that Petaluma's own Mickey Mouse Club was formed. In 1979, the building became known as the Phoenix Theatre. This 1950s photograph shows the California Theatre being remodeled once again. (Courtesy of the Sonoma County Library.)

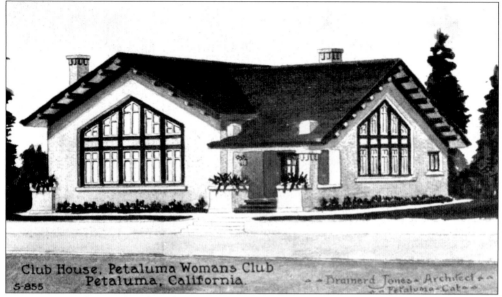

Club House, Petaluma Womans Club
Petaluma, California.
S-855
- - Brainerd Jones - Architect - -
- - Petaluma - Cal - -

In 1913, according to local architect and Brainerd Jones expert Shawn Montoya, Brainerd Jones entered a design competition and was selected over well-known Julia Morgan for the commission of the Petaluma's Woman's Club on B Street. The building was constructed by Morris Fredericks and designed in the Craftsman style with Prairie-style windows. (Courtesy of the Sonoma County Library.)

Pictured here are several women seated on the front steps of the Women's Club. (Courtesy of the Petaluma Museum.)

In 1925, Brainerd Jones and Morris Fredericks teamed up again in the design and construction of the Camp Fire Girls Hut at 510 English Street. Mrs. Henry Reynaud donated the land upon which the building was constructed, and Jones prepared the plans and specifications free of charge. The building now serves as a residence. (Courtesy of the Sonoma County Library.)

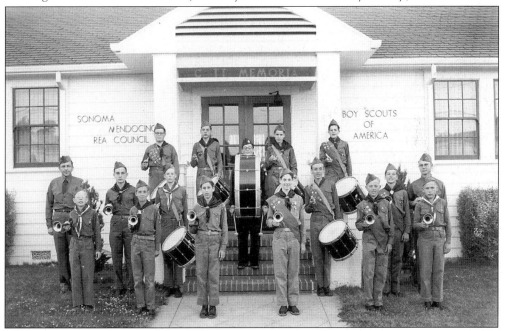

Brainerd Jones designed the Boy Scout building at 840 Western Avenue in 1932. H. P. Vogensen was the superintendent of construction. The building was constructed in memory of Tomales rancher Joseph Scott who, upon his death, donated a portion of his estate to his friends, C. A. LeBaron and William Mitchell, who were instructed to put the money to good use. Like the Camp Fire Girls Hut, this building has been converted to a private residence. (Courtesy of the Sonoma County Library.)

The first round of golf in Petaluma was played on June 18, 1922, at the newly completed Petaluma Golf and Country Club, which was located on land donated by G. P. McNear. The club officially opened on September 24, 1922, and in the spring of 1924, Al Herman, a well-known Penngrove contractor, built the clubhouse. In addition to donating the land for the country club, McNear donated maple flooring for the clubhouse and provided a $10,000 interest free loan. Brainerd Jones designed the building in what might be classified as "minimally traditional," which McAlester and McAlester describe in their book, *A Field Guide to American Houses*, as a cross between Tudor and Ranch. (Courtesy of the Sonoma County Library.)

Golfers tee off in front of the country club in 1959. (Courtesy of the Sonoma County Library.)

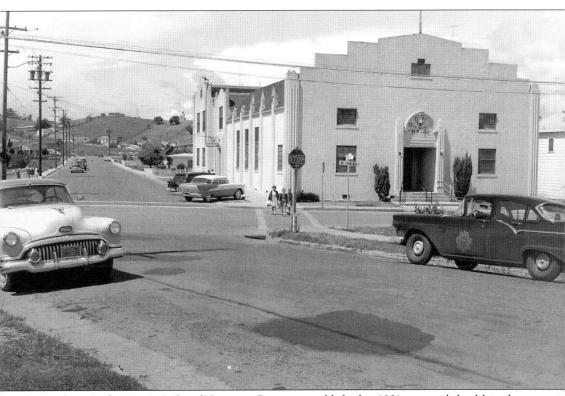

The Petaluma Lodge No. 2, Order of Hermann Sons was established in 1901 to provide health and death benefits for its members and to assist newly arrived German immigrants in getting settled. It was not until 1930 that the Hermann Sons Hall was built at the northeast corner of Western Avenue and Webster Street to serve as a cultural center for German-speaking people of Petaluma. Designed in the art deco style that was popular during the 1930s and 1940s, this building has a balanced and symmetrical form, smooth wall finish, and detailing and decorative piers to provide a vertical emphasis. Although a modest example, the Hermann Sons Hall is one of just a few art deco buildings to be found in Petaluma. (Courtesy of the Sonoma County Library.)

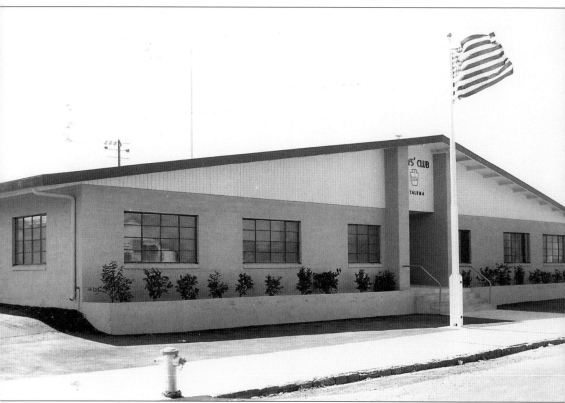

Groundbreaking for the first Boys Club, later the Boys and Girls Club, was held in 1957. This building, now known as the Cavanaugh Center, is located at the northwest corner of G and Eighth Streets. The idea originated in 1949, when a group of businessmen found themselves discussing ways to provide activities for boys. August Lepori, a leader in the effort, became president of the board of directors. A fund-raising campaign with a goal of $60,000 was launched in 1953 to construct the clubhouse. Pledges of cash, labor, and materials flowed in for a building that included a craft shop, library, game room, director's office, kitchen, and shower. The clubhouse has a typical 1950s design characterized by a low-pitch gabled roof, wide eave overhang, lack of decorative detailing, and a low, horizontal elevation influenced by Prairie-style architecture. (Courtesy of the Sonoma County Library.)

*Eight*

# PLACES CALLED HOME

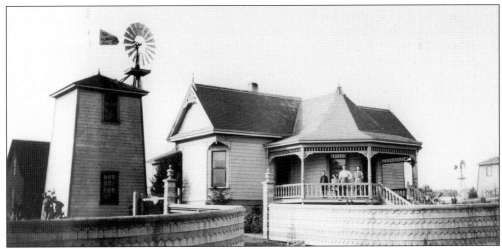

This Queen Anne farmhouse and its outbuildings, located at the southwest corner of Bodega Avenue and Paula Lane, is a typical example of the many small farm complexes that dotted the Petaluma landscape during the late 19th and early 20th centuries. People who settled in the area were lured by the promise of owning and operating a chicken ranch, generally five acres in size, in a town that by 1918 was proclaimed the "Egg Basket of the World." (Courtesy of the Sonoma County Library.)

Petaluma contains an impressive array of residential styles spanning a period of over 140 years. The Soberanes home at 421 East Washington Street, a modest Gothic Revival–style residence, may be one of the oldest in Petaluma. According to the late Bill Soberanes, local historian and *Argus Courier* reporter, his boyhood home was built by General Vallejo in 1850. The census shows the Soberanes family in residence as early as 1910 when Bill's father, Edward Soberanes, worked as a foreman at the nearby shoe factory. During the 1910s, Mr. Soberanes had the house next door at 423 East Washington Street built by local contractor M. B. Ingerson. Bill and his wife, Jane, moved into that house in 1983. (Courtesy of the Sonoma County Library.)

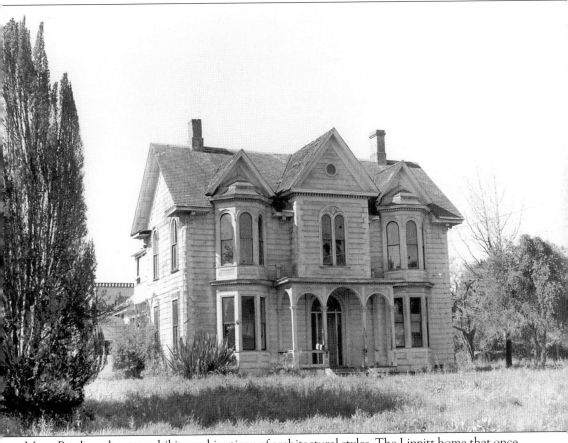

Many Petaluma houses exhibit combinations of architectural styles. The Lippitt home that once graced the southwest corner of D and Sixth Streets is such an example. This Gothic Revival house also displays Greek Revival elements. Gothic Revival was popular between 1840 and 1880 and is characterized by a steeply pitched roof, usually with a cross gable, rounded and arched windows, and one-story porches commonly supported by Gothic arches. All of these features existed in the Lippitt home, but the gable end returns suggest a Greek Revival influence. The house was reportedly built in 1867 for Prof. Edward S. Lippitt and his family. Lippitt built Petaluma's first private academy on D Street and later practiced law. In 1874, he was appointed chief counsel of the San Francisco and North Pacific Railway Company. Pres. Rutherford B. Hayes, Lippitt's former law partner, visited the home in 1880. Dr. Edward Baker purchased the property in the early 1940s, not too long after the death of Edward Lippitt Jr., a noted music teacher. Baker's original intention was to put a medical office building on the property, but those plans fell through, and the house was converted to apartments and then demolished in 1959. (Courtesy of the Sonoma County Library.)

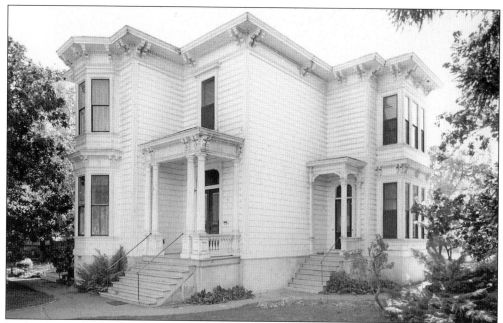

During the 1870s and 1880s, Petaluma saw the construction of a number of Italianate buildings, which are typically two to three stories in height, have a low pitched roof with widely overhanging eaves that display decorative brackets beneath, and tall, narrow windows frequently adorned by elaborate crowns. One of the best examples of this style is the former home of Henry and Addie Atwater at 218 Fourth Street, built by contractor L. G. Nay for Capt. Jesse C. Wickersham in 1871. Wickersham appears to have sold the house to the Atwaters shortly after its completion. Henry Atwater was a prominent banker and Addie was president of the Ladies Improvement Club, responsible for the creation of many Petaluma parks, including Walnut Park, located directly across from the Atwater home. (Courtesy of the Sonoma County Library.)

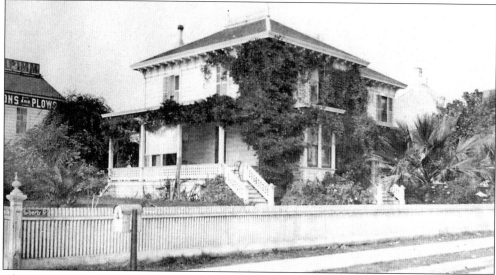

The Zartman home at 111 Liberty Street is another example of the Italianate style. William Zartman, along with John Fritsch and James Reed, established Petaluma's first carriage and wagon factory. (Courtesy of the Sonoma County Library.)

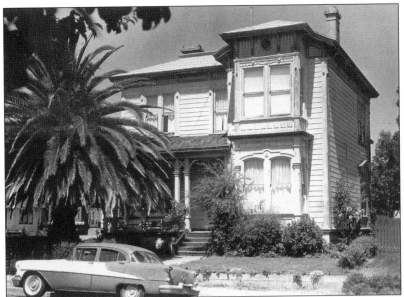

The old St. Vincent's rectory at 338 English Street is another example of the Italianate style. Built in 1883, this house was moved to its present location in 1915 and is the former home of Petaluma Mayor Vincent Schoeningh. In 1978, a major restoration was completed on the house, returning it to a single-family residence after having been divided into five apartments years earlier. (Courtesy of the Sonoma County Library.)

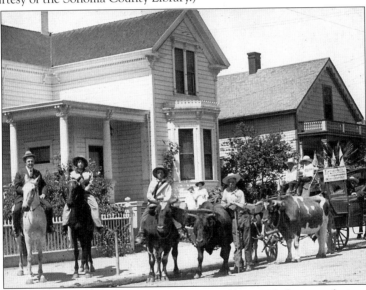

The former home of Sabina Tomasini, shown at left in this 1916 photograph, is an example of the vernacular L-shaped farmhouse that draws on at least two different styles commonly found in 19th-century Petaluma residential architecture, including Greek Revival and Italianate. The gable end returns and the tall, narrow windows suggest influence of the Greek Revival style, while the squared front bay and window crowns are more closely associated with Italianate. Historic maps suggest that this house went through a series of remodels, which may explain the presence of different architectural styles. A tanning salon now occupies the lot where this house once stood at 6 Fifth Street. (Courtesy of George Tomasini.)

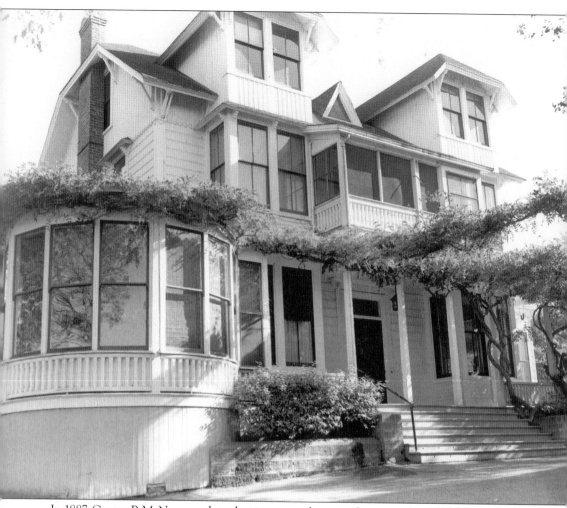

In 1887, George P. McNear purchased a picturesque home and property located where the McNear Landing subdivision stands today. The house was built around 1881, and the McNear family occupied it for over 70 years. A real estate developer purchased the property in 1971 with plans to build condominiums on the roughly 17-acre parcel. The developer did not want the historic house and offered it to Heritage Homes, who were not able to pay the $30,000 that house-moving experts estimated it would cost to relocate it. An auction was held and many items associated with the house were sold with proceeds going to Heritage Homes. Bits of the McNear mansion can be found throughout Petaluma with remnants of fencing on D and Howard Streets, a light fixture installed as a porch light at a home on Oak Street, the mansion's electric stove going to the owner of a house on Petaluma Boulevard North, and so forth. The house was razed in 1972. Much of the flooring and other building materials went to the demolition contractor, Willliam Vartnaw. The condominium project never came to fruition. The homes currently located on the site were built in 1997. (Courtesy of the Sonoma County Library.)

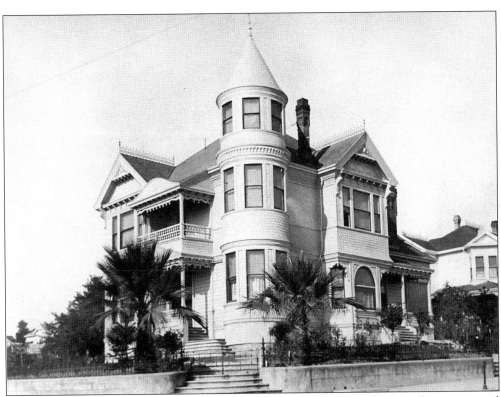

The Queen Anne was popular from about 1880 through 1910 and featured a typically asymmetrical form and steeply pitched roofs of irregular shape. A dominant front-facing gable is usually present as are patterned shingles and other elements that eliminate a smooth wall texture. Cutaway bay windows and one-story wraparound porches are also common. Some Queen Annes were built with a circular tower such as the Haubrich/Brown house on Keller Street, seen here. Contractor Samuel Rodd built this house in 1892 for Sarah and Leonard Haubrich. Sarah died in 1906 and the house went to her son from an earlier marriage, Robert Brown. He had his name incised over that of Leonard Haubrich on the carriage step set on the sidewalk facing Keller Street. (Courtesy of the Sonoma County Library.)

The Henry and Elizabeth Poehlman house at 300 Fourth Street is another example of a Queen Anne on a more modest scale. Henry Poehlman owned and operated a butcher shop. (Courtesy of the Sonoma County Library.)

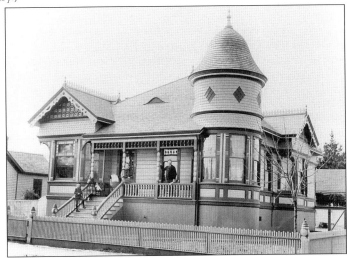

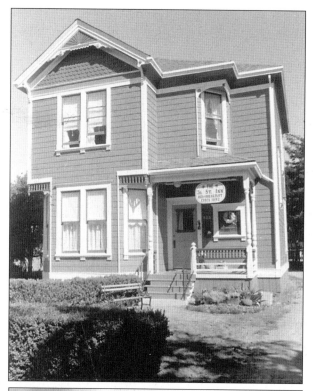

The former home of contractor Morris Fredericks at 525 Seventh Street is an example of what some might call a Queen Anne farmhouse. Morris Fredericks, seen below as a young man, moved into this house with his wife, Theodora, and their three children in 1886 (three additional children were born between 1887 and 1892). Fredericks did construct a small cottage on the property for his mother who was brought to Petaluma from the Isle of Fohr following the death of his father in 1886. Many of Petaluma's homes and business structures were built by Morris Fredericks. In addition to his contracting business, Fredericks assisted in drafting the city charter that was adopted in 1910. He was elected to the Petaluma City Council in 1911 and served as chairman of the finance committee and fire commission. He was also an active member of the Petaluma Volunteer Fire Department. (Courtesy of the Petaluma Museum and Dorothy Bertucci.)

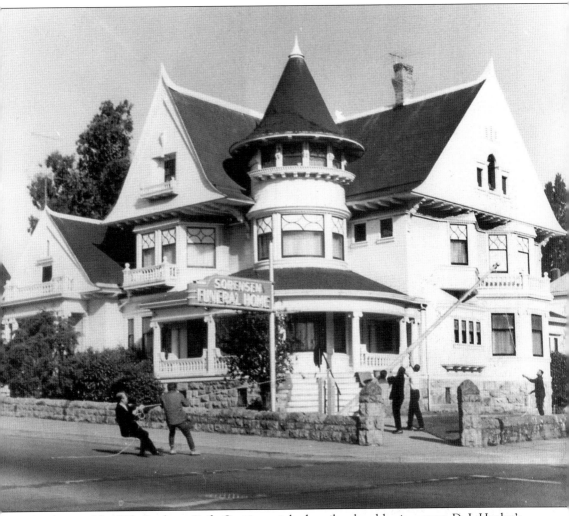

An August 26, 1902, *Petaluma Daily Courier* article describes local businessman D. J. Healey's plan to construct a new home at 400 Washington Street. The article lists the contractor as Rodd & Rodd, and the architect as J. Cather Newsom of San Francisco, the same architect who, along with his brother, designed Petaluma's city hall. Other sources cite the architect as Brainerd Jones. Whatever the case may be, the Healey home was quite an addition to Petaluma at the time, and its demolition in 1969 was considered a significant loss to the community. At the time the house was razed, it was occupied by the Sorensen Funeral Home. William Sorensen purchased the property from D. J. Healey's widow, Margaret, in 1939. The house was replaced by a Union 76 service station, which has since been removed, and all that remains is a vacant lot. (Courtesy of the Sonoma County Library.)

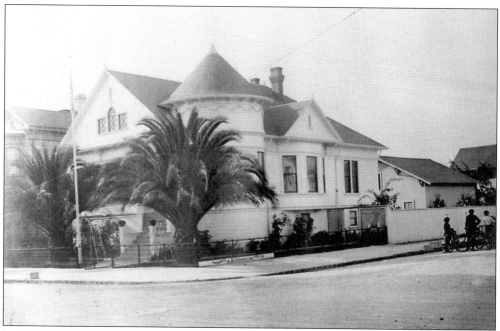

In 1903, Morris Fredericks built a home in the Queen Anne style for William Bourke at 15 Howard Street. (Courtesy of the Sonoma County Library.)

The former home of Edgar Raymond, of the Raymond Brothers Department Store family, is another example of the Queen Anne style. This photograph shows the house as it appeared around 1904. Edgar and his wife, Sarah, and their daughter Mary occupied this house at 314 Seventh Street for many years. (Courtesy of the Sonoma County Library.)

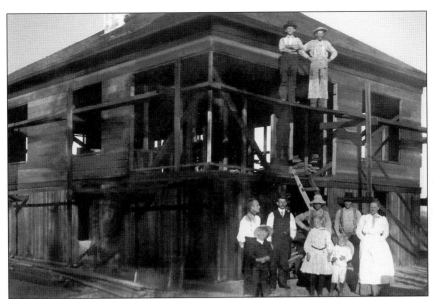

At the turn of the 20th century, Petalumans saw a number of smaller homes being constructed, both in the rural areas to accommodate newly arrived chicken ranchers and in town, where jobs at feed mills, hatcheries, and manufacturing plants provided jobs that paid a modest income. Examples in rural areas include the Hansen house at 718 North McDowell Boulevard. Built in 1906 by Danish immigrants Anna Marie and Hans Hansen with help from Anna's family, this house was just one of many farmhouses on the east side of Petaluma. The Hansens were chicken ranchers, and Anna also served as a midwife. In July 2003, the house was declared a local historic landmark. Six months later, vacant and unprotected, the house caught fire. Here it is under construction. (Courtesy of the Hansen family.) Below is the house as it appeared January 2001. (Photograph by Katherine J. Rinehart.)

Not far from the Hansen property was the Henry and Anna Graff ranch on Corona Road. Newly arrived from Minnesota, Henry and Anna and their three young children settled on an 18-acre parcel they bought from F. H. Denman in 1900. Henry Graff soon established himself as a major figure in the Petaluma chicken industry, as he worked with A. R. Coulson to perfect chicken feed. Graff was known for his high-grade fowl, which he sold for breeding purposes. The hatchery on the property had a capacity for 40,000 eggs, which were sold to Must Hatch and other hatcheries. The Graffs remained on the property until 1938 when financial hardship forced them to sell all but one acre of their ranch to the Central Bank. A barn and tank house, somewhat modernized, are all that remain of the Graff ranch, which currently has the address of 464 Corona Road. (Courtesy of Herb Graff.)

Several early 20th-century cottages built to address the need for affordable housing can be found in the Riverfront Warehouse District. Local stonemason and contractor William S. Stradling appears to have built a number of homes in this neighborhood, including 200 H Street, which was constructed around 1908. Swiss-born Bernard and Caroline Tonini and their children rented this house from at least 1910 to 1928. The children included Bernard Jr., who worked as a mixer in a feed store; Eugene, who was a butcher; daughter Erma, who worked as a seamstress at the nearby overall factory; and daughter-in-law Hattie, who was employed at a box factory.

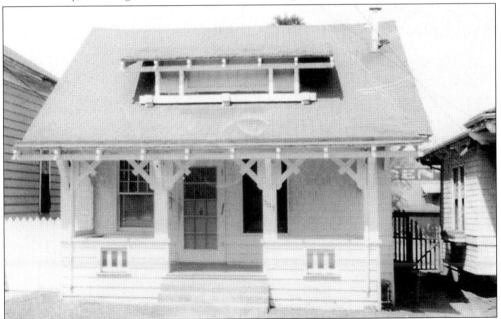

Petaluma's first full-time fire chief, Lucien Benoit, lived in this neighborhood for many years in a house that he and his wife, Lillian, rented at 503 Second Street. This Craftsman-style bungalow was built around 1907.

115

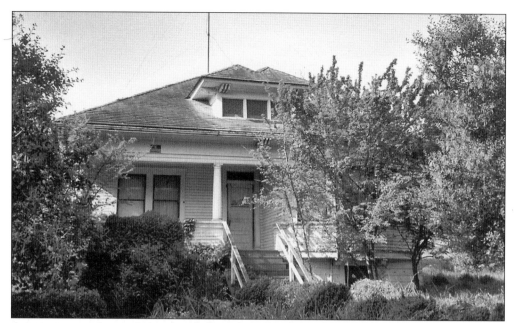

A very common house design found throughout Petaluma during the late 19th and early 20th centuries that defies specific architectural labeling is evidenced in those homes that are typically square in shape, one to one-and-a-half stories in height, have a hipped roof with wide eave overhang, and possess rounded front porch columns. Other detailing sometimes includes fish scale shingles, dormers, and rounded porch entryways. This vernacular style draws on aspects of the Colonial Revival, Queen Anne, and sometimes Craftsman detailing depending on the year of construction. The Neunfeldt home at 674 Sunnyslope Road is one example of this style. Fred Neunfeldt was born in this house in 1898. His parents, Albert and Isabella, operated a chicken ranch on the property. In 1913, Fred married a woman named Stella and together they lived in the house with their daughter Betty. Fred was in the car business for a number of years. He died in 1949, and Stella continued living in the house. She died in 2002, living over 100 years, with most of those spent at 674 Sunnyslope Road. The property upon which the Neunfeldt home sits is being considered for development. (Photograph by Katherine J. Rinehart.)

Note the interesting double-hipped dormer and decorative bracket detail that is often associated with the Craftsman style. (Photograph by Katherine J. Rinehart.)

116

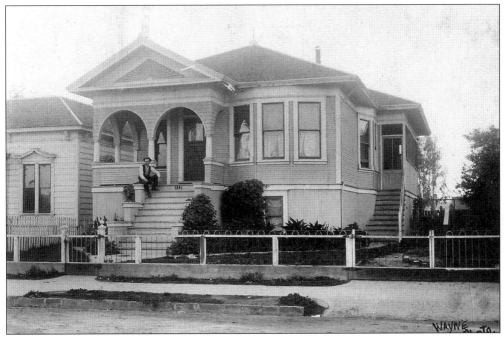

Built between 1894 and 1906, the Guido and Iris Boccaleoni home at 415 East Washington Street combines elements of the Queen Anne with pediment above the front porch and with Colonial Revival in the use of rounded columns and arches. (Courtesy of Jane Soberanes.)

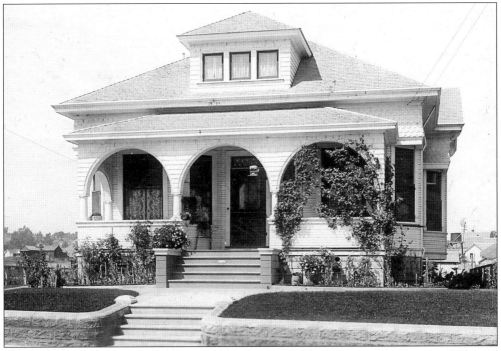

The Bolla family home at 734 B Street, shown here in 1921, was constructed between 1906 and 1910 and also has Queen Anne and Colonial Revival elements. In this case, the use of fish scale shingles reflects the Queen Anne influence. (Courtesy of George Tomasini.)

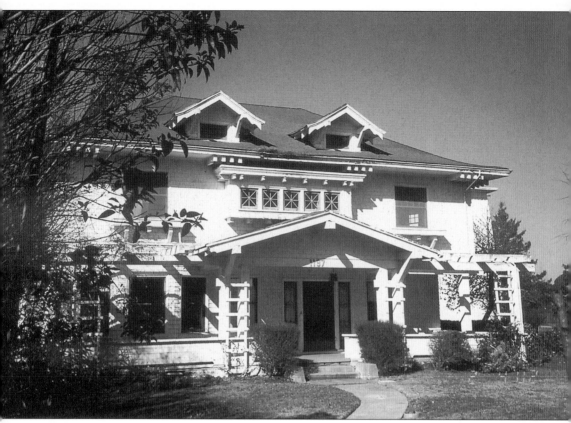

Between 1905 and 1930, the Craftsman style was quite popular. Typical characteristics include a low-pitched gable roof with wide, unenclosed eave overhang. Triangular knee braces are found beneath the gable ends and roof rafter tails are usually exposed. Porches, either full or partial width, are supported by wood or stone columns. Examples include the Martin house, a local landmark located at 1197 East Washington Street. Brainerd Jones designed this house for John Ellis in 1911. Leopold Martin bought the property in 1920 and until recently the house was owned by descendants of the Martin family. Current plans for the property include turning it into an 18-lot subdivision with the main house retained as offices and the remaining parcel converted to 10 duplexes and seven single-family homes. A large barn and tack house on the property would be demolished, and an existing tank house would be used as an accessory dwelling to accommodate the new development. (Photograph by Katherine J. Rinehart.)

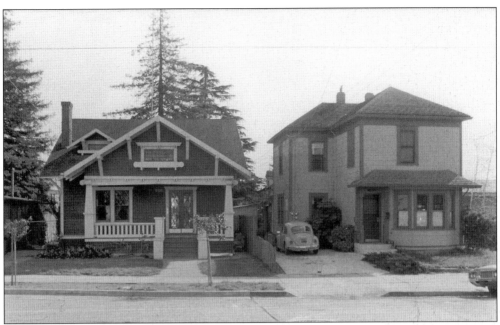

A classic example of the Craftsman bungalow can be found at 3 English Street, shown on the left in this 1978 photograph. Built between 1910 and 1919, this house was rented to Robert and Lucy Conley in 1920. Later members of the Perinoni family owned and occupied the house. Guiseppe and Maria Perinoni were Swiss Italians who had rented a neighboring house at 120 English Street for a number of years before purchasing 3 English Street around 1924. Their daughter Ida, a longtime clerk at the post office, remained here until her death in 1975. (Courtesy of the Petaluma Museum.)

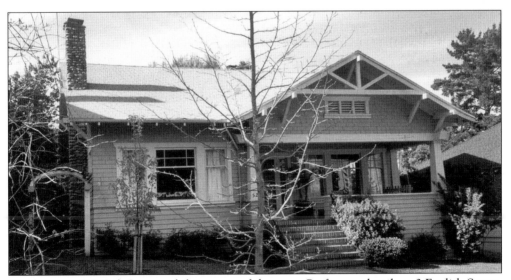

The home at 528 Oak Street exhibits many of the same Craftsman details as 3 English Street. In 1911, Brainerd Jones designed this house for assistant postmaster Ernest Wilder and his wife, Mabel. (Photograph by Katherine J. Rinehart.)

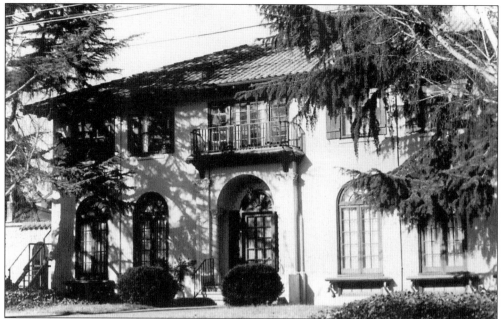

Mediterranean-inspired architecture was all the rage during the 1920s and 1930s in Petaluma. Examples include the former Henry and Jeanne Reynaud home at 47 Sixth Street, which was built in 1924 by Morris Fredericks and designed by Brainerd Jones. Henry Reynaud was a successful merchant, and Jeanne Reynaud was well known for her community service, which included such contributions as the Camp Fire Girls Hut on English Street. (Courtesy of the Sonoma County Library.)

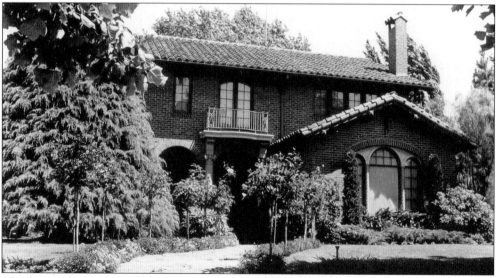

The former Tomasini residence at 625 D Street, also designed by Brainerd Jones, is similar in appearance to 47 Sixth Street, but instead of a stucco exterior, bricks were used. Contractor Walter Singleton built this house in 1929 for Americo F. and Esther Tomasini. A. F. Tomasini, as he was called, was a prosperous and civic-minded Petaluma businessman who is still remembered for his generosity as well as his hardware store on Kentucky Street, which later moved to Keller Street and was managed by his son, George. (Courtesy of the Sonoma County Library.)

In 1923, Lizzie Wickersham Maclay and her husband, Thomas Maclay, commissioned renowned San Francisco architect Albert Farr to design a 12-room house in the Mediterranean Revival style on their property at 600 D Street. Vogensen Construction Company built the house, which replaced an earlier residence that had been the Wickersham mansion. (Courtesy of the Sonoma County Library.)

A portion of the old Wickersham home, shown above, was moved to 508 Petaluma Boulevard South by Thomas and Mabel Burger who converted it to the Redwood Inn. In later years, it was known as the Rose Court Hotel. Today people know it as the Metro Hotel. (Courtesy of the Sonoma County Library.)

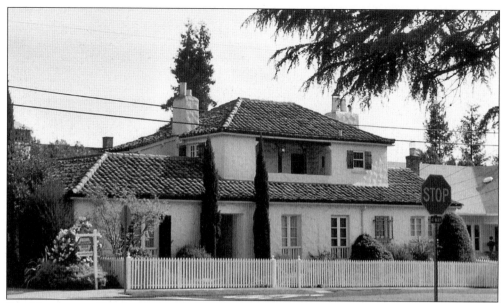

Possibly impressed by the Maclay home, Dr. Hugo Fleissner, a local dentist, hired Albert Farr in 1929 to design a home at 201 Eighth Street for himself and his wife, Lillian. Contractor Walter Singleton built the house and featured it in his book *Homes of the Moment, Built to Last*. Although built for the Fleissners, this home is more closely associated with Clarence and Cecilia Miller who bought it in 1931. Clarence Miller, president of Kresky Manufacturing, was a city councilman at one point in his career, was active with the chamber of commerce, and cofounded Thomas-Miller and Company, a real estate firm responsible for constructing a number of Petaluma subdivisions. (Photograph by Katherine J. Rinehart.)

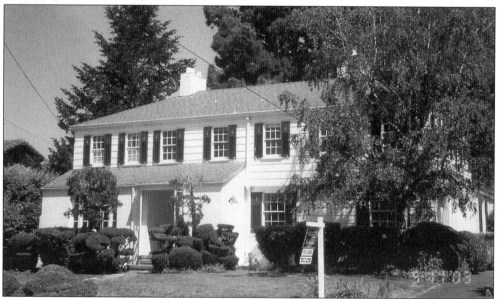

Albert Farr also designed this Colonial Revival home at 635 D Street for Dr. David Davis and his wife, Helen. Davis was a pharmacist who owned the Chicken Pharmacy on Main Street, now Petaluma Boulevard North. Many remember this house for its connection with Leroy and Helen Lounibus. (Photograph by Katherine J. Rinehart.)

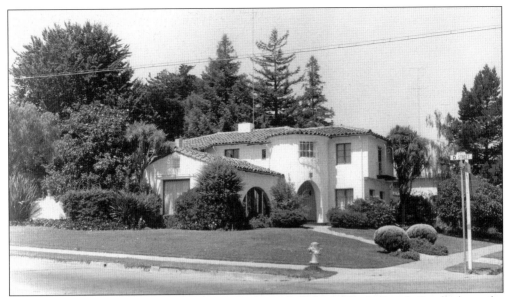

Architect Don Uhl of Los Angeles chose the Spanish Colonial Revival style for the home he designed for Carl and Juanita Behrens in 1930. The house, built by A. M. Seeberg, is located at 900 D Street. Carl Behrens was the founder and principal owner of Hunt and Behrens, a grain, feed, and poultry firm established in 1921. In later years, the Behrenses moved to 4 Brown Court, and the house at 900 D Street was purchased by Leland and Helen Myers. Leland Meyers owned L&M Pharmacy. (Courtesy of the Sonoma County Library.)

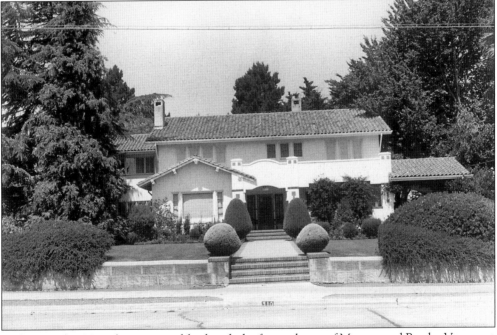

Built around 1923 in the same neighborhood, the former home of Magnus and Bertha Vonsen at 910 D Street was designed in the Mission Revival style. Like Carl Behrens, Magnus Vonsen was an important player in the Petaluma feed business as the president of the M. Vonsen Company. (Courtesy of the Sonoma County Library.)

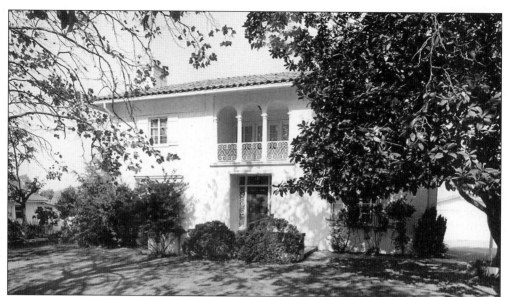

Angelo Agius hired Julia Morgan to design his house at 210 West Street. Built in 1937, the house represents the Mediterranean style characterized by a low-pitched roof covered with ceramic tiles, arched openings, upper-story windows that are smaller and less elaborate than the ground floor windows, the presence of wrought iron grill work, and a symmetrical facade. Although Morgan designed the house, it appears that the plans were prepared by one of her employees, Jack Wagenet. The San Francisco firm of Cornelius, Meyer, and Cornell were the builders of the house. (Courtesy of the Sonoma County Library.)

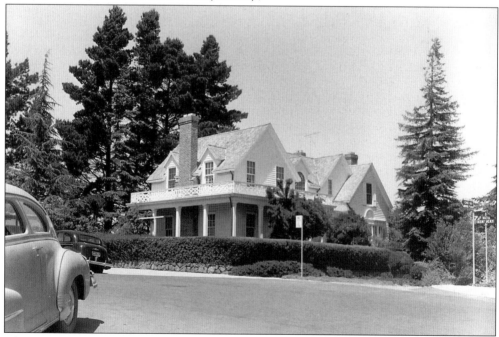

Julia Morgan is also credited with building this Colonial Revival/Cape Cod home at 14 Martha Street for J. H. Gwinn, one of the founders of the Petaluma National Bank. (Courtesy of the Sonoma County Library.)

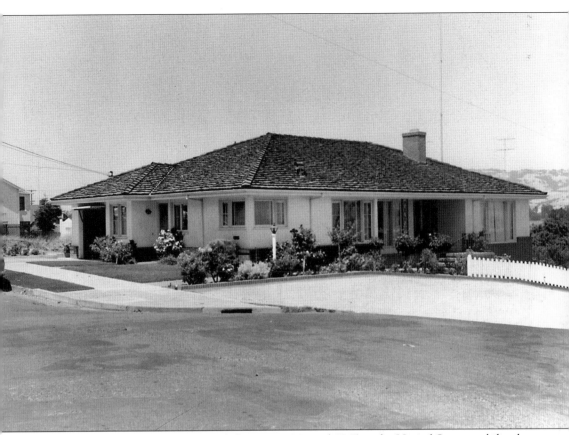

Home construction slowed significantly between 1941 and 1945 as the United States mobilized and fought in World War II. After the war, residential design changed dramatically with the introduction of the ranch, a sprawling design that replaced earlier, more compact homes. Ranch-style homes are typically one story, have low-pitched gable roofs with deep-set eaves, posses a horizontal or rambling layout, are asymmetrical, have large windows, attached garages, simple floor plans, and emphasize openness. An excellent example of this style is found at 500 Keller Street. So Mar Company built this house for William and Marie Deiss in 1949. William Deiss was a partner in So Mar as well as a successful businessman and realtor who served on the city council for 16 years. He was instrumental in the development of the La Cresta and Linda Vista subdivisions. (Courtesy of the Sonoma County Library.)

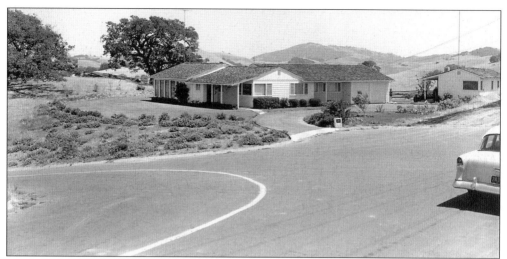

After World War II, suburban tracts sprang up across the country to meet the housing needs of returning GIs and their families. In Petaluma, this trend was reflected in the construction of La Cresta Heights, a 20-acre tract development that contained 67 building lots for which ground was broken in May 1946. The smallest lot in the subdivision was reported to be 100 by 150 feet and the largest 100 by 175 feet, "thereby affording ample room for large homes and extensive landscaping." An *Argus Courier* article dated May 14, 1946, describes how restrictions based on race, livestock, landscaping, and architecture were to be invoked for this new housing development. Shown here is a 1960 view of a La Cresta Drive home. (Courtesy of the Sonoma County Library.)

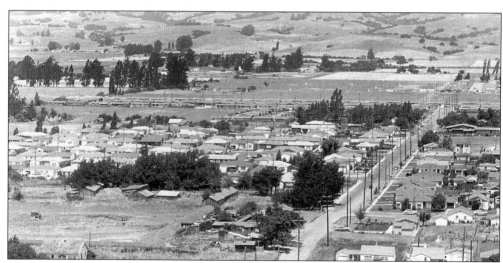

The Madison Square subdivision, which called for the construction of 60 new homes in an area bound by Washington, Vallejo, Madison, and Payran Streets, was also built in 1946. Veterans were given preference of purchase for 30 days after completion. The selling price was approximately $7,000. Here is a view of Madison Street looking east in 1956. (Courtesy of the Sonoma County Library.)

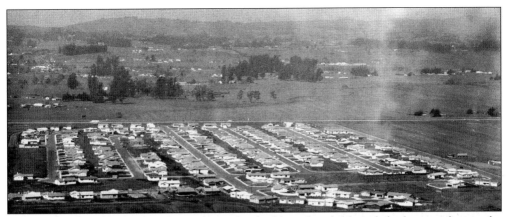

It was not too long before development on what had been hay fields and chicken ranches on the east side of Petaluma took hold. The caption on this photograph reads, "New tract homes in east Petaluma 1947." (Courtesy of the Sonoma County Library.)

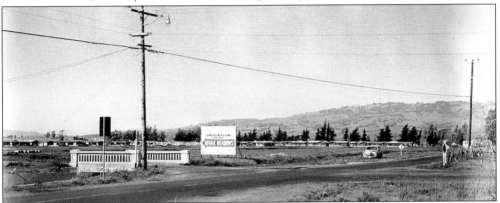

Pictured in the early 1950s is the intersection of East Washington Street and McDowell Boulevard. Note the sign pointing to Novak Meadows.

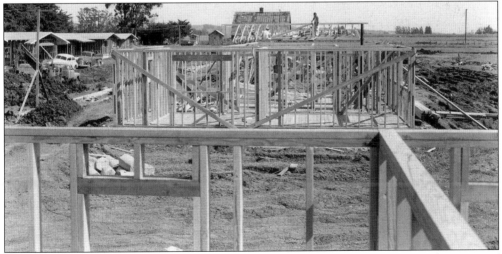

In April 1956, homes were under construction as part of Novak Annexation No. 3. (Courtesy of the Sonoma County Library.)

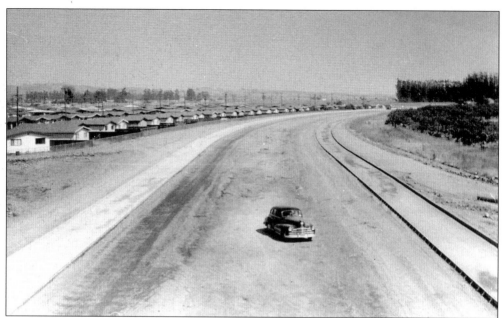

By 1951, McDowell Village (left), a residential subdivision bound by McNeil, McDowell, McKenzie, and Coronado Streets, had been built in anticipation of the completion of Highway 101. (Courtesy of the Sonoma County Library.)

In 1957, Highway 101 was completed, bypassing downtown Petaluma. Ever since, East Petaluma has meant east of the highway, not east of the Petaluma River. This view of the new highway was photographed from the Dutra rock quarry. In June 2005, the Petaluma City Council approved construction of a 250-home residential subdivision including 170 houses and 80 condominiums on the site of the former quarry. This conversion of industrial land to residential use signifies the strong development interests that currently exist in Petaluma. (Courtesy of the Sonoma County Library.)